Jerry N. Uelsmann

Cover photograph Apocalypse II 1967

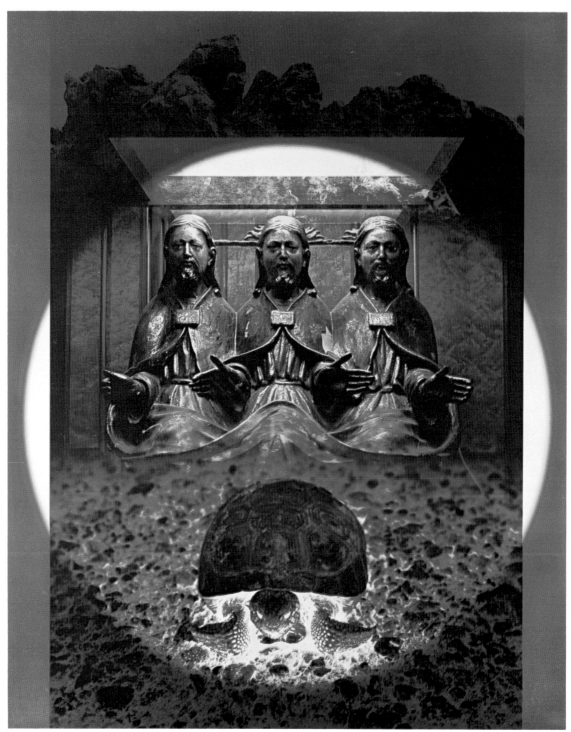

Turtle Blessing 1968

Jerry N. Uelsmann

introduction by Peter C. Bunnell fables by Russell Edson

An Aperture Monograph New York

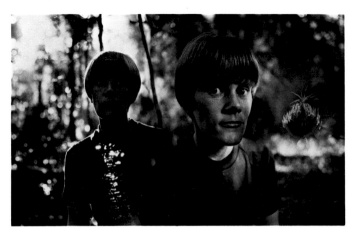

for Marilynn *1970*

A special note of gratitude

to my three photographic godfathers:

Ralph Hattersley, Minor White, and Henry Holmes Smith,

each of whom answered me

with more beautiful questions.

Aperture, Inc. is a non-profit, educational organization publishing a Quarterly of Photography, portfolios, and books to communicate with serious photographers and creative people everywhere. Address: Elm Street, Millerton, N.Y. 12546.
Revised, Enlarged Edition

INTRODUCTION

Although I believe my work is basically optimistic, I would like people to view my photographs with an open mind. I am not looking for a specific reaction, but if my images move people or excite them I am satisfied.

I have always felt I photographed the things I loved.

*My images say far more than I could say in words. I believe in photography as a way of exploring the possibilities of man. I am committed to photography and life...and the gods have been good to me. What can I say. Treat my images kindly, they are my children.**

In his humanity Jerry Uelsmann is impressively real, yet his photographs, born of a fantast's vision, manipulate our deepest and most fundamental emotions, prompting us to suspect his person in art to be romantically independent of the real. He possesses a rare inspiration which effortlessly moves us. Like all true artists he is motivated by enthusiasm, and by the enjoyment of creation which drives him to share his dreams and experiences with us. Unconsciously, we are under his control and this control has been crucial to his success. His art is essentially direct rather than allusive and his pictures appear analogous to that believable reality so fundamental to photography. But herein is the rub; Uelsmann's interpretative vision pervades each work and causes us to ponder whether reality is really quite so true as invention. Perhaps more consistently than any other photographer of his generation he has sought what Apollinaire called art's greatest potential—surprise.

Upon its introduction photography was understood in terms of a mystery related to its process alone. In recent years this mysterious or even mystical regard has been transferred to the photographer. Today he has become the pivotal figure in a creative metamorphosis which links sensory experience and physical process in such a way so as to reveal in a picture something much greater than the depiction of any subject or thing. What

**These quoted statements are from Uelsmann's lectures, his letters, his conversations with the author, and from his published remarks.*

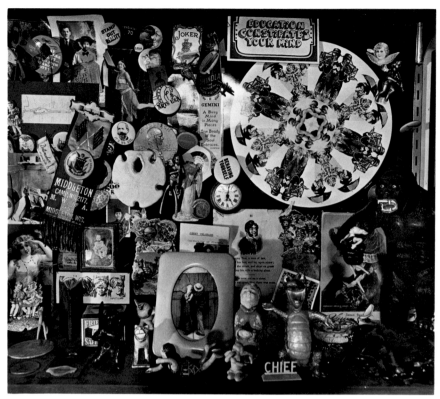

The Wall Behind My Desk

we have come to realize is that the frame of a photograph marks only a provisional limit; that its content points beyond that frame, referring to a multitude of phenomena which cannot possibly be encompassed in their entirety. Thus creativity in photography is the exposition not only of the photographer's receptivity in observation, or the skill of his craftsmanship, but the delineation of spirtual reality wherein the symbol transcends its model.

In the depths of any art must reside a personality, and like an instinctive animalistic struggle to recover from birth, the artist aspires to express his *self* in his work. How lacking in courage is an art in which the creator examines the collective ideal as opposed to the self-centered individualism of his own being. The key to a work of art lies not only in the work itself, but in the artist's outward labor to be someone. Uelsmann's life, his manners, his physical being, his work, all that forms the aggregate of his personality, imparts a final impression experienced at once as both dark and dazzling.

Basically I am dealing with the predicament and condition of man as it directly involves me as an individual.

I have gradually confused photography and life and as the result of this I believe I am able to work out of my self at an almost precognitive level.

Life relates to attitudes. I have my own attitudes to work with, my own ritual, my game of involvement. Images create other images. I cannot be asked to be some-thing other than what I am, but I enjoy mind-prodding and mind-stretching.

Learn to use yourself as an instrument.

I first met Jerry Uelsmann at the Rochester Institute of Technology fifteen years ago when we were both students. I don't recall knowing him well—he wasn't making photographs then—but he was the kind of person one always knew was around. He had a kind of flamboyance and vitality which can only be described as humor.

Jerry's humor remains with him today and while it is no less discerning than wit, it has much of the uninhibited earthiness of vaudevillian comedy. It is reflected in his speech, his mildly eccentric clothes, his mania for col-lecting bric-a-brac, and in his phantasmagorical letters some of which in-clude handwriting, photographs, Victorian valentine stickers, Laurel and Hardy vignettes, peace symbols, and Florida gator heads. It could never be thought that he conducted anything like an old world salon in Gaines-ville, but a typical "at home" with the Uelsmanns might begin with libations followed by a superb lasagna prepared by his wife Marilynn for a dozen or so people, include a visit to the University of Florida campus for a screen-ing of the complete Flash Gordon serials run end to end, followed by dessert at Dipper Dan's, and climaxed by a return to the house for a raucous songfest of maudlin church hymns and nifty songs from the twenties con-ducted, orchestrated, and played with consummate endurance on the grand pianola pedaled by Jerry himself. He has frequently remarked that

he prints his photographs best to Beethoven and Bluegrass; and although Earl Scruggs would make a perfect name for his extremely gentle watchdog, he chose instead to name her after a once famous animal photographer. An addict for musicals of the largest, gaudiest, Broadway variety, Jerry entertains a secret desire to be a tap dancer and he would also admit to a love affair with Shirley Temple; that is, before she became an ambassador to the United Nations.

Social humor and amusing antics are significantly absent in Uelsmann's photography, and it is in his photographs that the darker facets of his being become apparent. For one cannot escape the belief that his comedy conceals an intensity of concern for life and personal doubt which Jerry harbors about life's meaning. Indeed his interest in photography goes back to the time when, as a teenager, he discovered he could use the camera to divert attention from himself, or to have it function as a kind of buffer in personal encounters. He thought that in so using the camera—or photography—he could exist outside of himself, an idea he would realize in his later life to be naïve. Jerry is passionately in love with life but behind his exuberance is a coldly determined intention to seek the means of expressing the human condition in the most visible way. He understands perfectly well what he is doing. Although he publicly claims innocence in his creations, subtly redirecting inquiries about his approach to the concept of what he calls "in-process discovery," he assuredly possesses what a stranger to him described as "shadow wisdom." Such sagacity befits this double Gemini.

> Let us not delude ourselves by the seemingly scientific nature of the darkroom ritual; it has been and always will be a form of alchemy. Our overly precious attitude toward that ritual has tended to conceal from us an innermost world of mystery, enigma, and insight. Once in the darkroom the venturesome mind and

spirit should be set free—free to search and hopefully discover.

I can really be excommunicated from the world in the darkroom.

In the darkroom, a comfortable kind of situation is needed; for me the darkroom experience seems to relate to the cosmos outside—in fact, the experience seems to relate to an internal/external cosmology. There is the opportunity for an internal dialogue in the darkroom...a turning inwardly relative to what has been discovered outside...the two coming together. I develop an attitude toward something I am working on and can spend ten hours or more without becoming uncomfortable. I am creating something while I am working...not just technical orientation...really I am midwifing images and this is sort of what I am about. I see myself in terms of my self.

Today the artist, more than the priest, reveals the existence of an intangible extrasensory force which is constantly affective in our life. The artist is the surviving exponent of the mysteries, the last believer in the duality of our world, the last teacher of the method whereby we may establish contact with the mysterious and convert the mysterious into the credible. By so completely absorbing the real world Uelsmann is able to go beyond it. He is able to annihilate it and to create in its absence visions and forms that man has hardly ever seen.

The excruciatingly complex techniques of photomontage are superbly suited to his effort. These techniques are Uelsmann's alchemy. His volatile photographic images, in which the dominant character is the dynamism of a psychic order, open to the world of magic. I do not believe he could ever satisfy himself with what is termed straight photography, because for him straight photography is not the resolution of a vision, but the beginning of a process. He takes pictures simply, rapidly, and straightforwardly, responding freely to the inspired revelation and recognition he achieves through the camera. With little or no preconceived notion of a finished photograph, he makes enormous numbers of negatives, stores them care-

fully, and in this way prepares his visual vocabulary for the next step.

In the darkroom he progressively and additively compiles the visual equivalent of his inner vision. He consciously follows the dictates of his insight in the construction of an image. His work would not be as convincing if it were not totally drawn from himself, and this means working with the negatives of no other photographer. It is the intimacy of the personal, half-forgotten image or event, recorded perhaps years previously, which is drawn from the negative file and brought into the light of a new consciousness. Every discrete step is the commencement of a new moment in his life, a fresh vision of reality, a rape of common sense.

One cannot look at the body of Uelsmann's work without recognizing in it the sustained effort, matched by few photographers of his time, to come to grips with all the problems of photography—to achieve in the end an unmitigated integrity of the whole. Nothing is left out. The failures are important; they matter profoundly. The struggle matters too; and in this age of easy images it probably matters most of all.

The contemporary artist in all other areas is no longer restricted to the traditional use of his materials…he is not bound to a fully conceived pre-visioned end. One of the major changes seen in modern art is the transition from what was basically an outer-directed art form in the 19th century to the inner-directed art of today. To date, photography has played a minor role in this liberation.

By post-visualization I refer to the willingness on the part of the photographer to revisualize the final image at any point in the entire photographic process.

The truth is that one is more frequently blessed with ideas while working.

An old Uelsmann negative gathers no moss.

I'm really very concerned with helping to create an attitude of freedom and daring toward the craft of photography.

IN THE SHADE OF THE OLD
APPLE TREE (4).
Chorus:
In the shade of the old apple tree,
 Where the love in your eyes I could see,
When the voice that I heard like the song of a bird,
 Seemed to whisper sweet music to me,
I could hear the dull buzz of the bee,
 In the blossoms as you said to me,
With a heart that is true I'll be waiting for you,
 In the shade of the old apple tree.

How's This For
An Innovation—
A Multiple-Printing-
Sing-A-Long
Photograph

Jerry is considered something of the *enfant terrible* of contemporary photography. Consciously drawing on the work of Robinson and Rejlander, two of the most misunderstood photographers of the last century, he sees himself as their successor. The aim of these men was to create a picture through the combining of photographic bits and pieces. Uelsmann elaborates the discipline to a more complicated and perfected form. Whereas Robinson and Rejlander used the composite photograph as a technique to fabricate a unified picture of a completed event or idea in conventional linear space and time, Uelsmann presents in his approach to photomontage simultaneously varying systems of idea and event as an analog for the inner and non-linear processes of thinking and feeling.

It is too soon to tell what Uelsmann's place will be in the history of photography. But we know even now that contemporary photography is not the same as it would have been without him. Many of us, perhaps all of us, feel richer in having experienced his work and this is something that happens infrequently in a lifetime. I feel confident that he will continue to provide for us the imaginative leap to a reality greater than anything we may otherwise observe.

Peter C. Bunnell

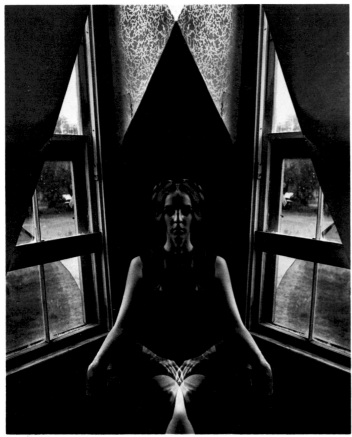

Quest of Continual Becoming 1965

IT.

It was someone as viewed in a mirror, or was it you
said it was someone viewing its someone who it is in a mirror
where perhaps someone lives only.
Someone is not the chair but part of where, where a table
and a blue in square is a window and some sky.

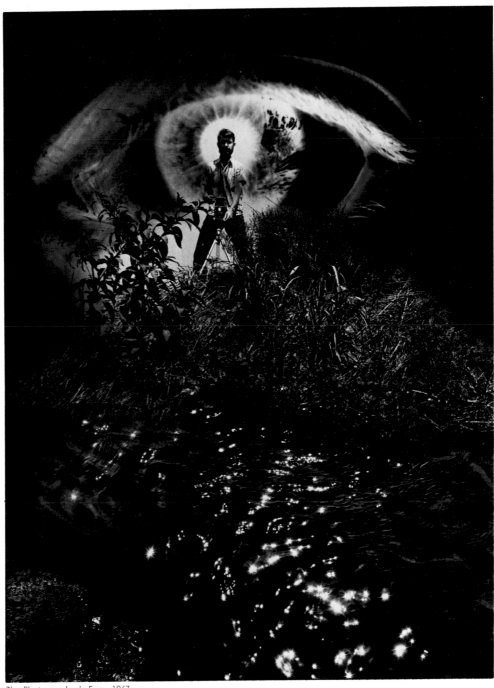

The Photographer's Eye 1967

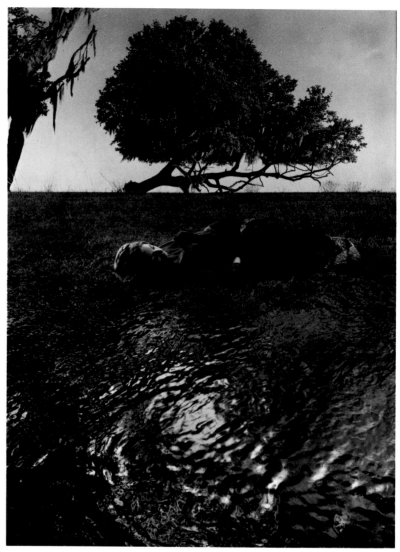

1966

MEMORY
AND THE
SUN

There was once a memory of a person that would not go even though
a person had said I do not like memories and died, for there was a habit
that needed badly to be repeated. A woman saw the sunshine coming
in a window looking through a memory to find a person to form a
shadow. He did not like memories or old persons he said, he did not like a
habit which is brown in a cup and cigarette turning to smoke. He did
not like the sun to repeat him on the wall or the woman to repeat him by

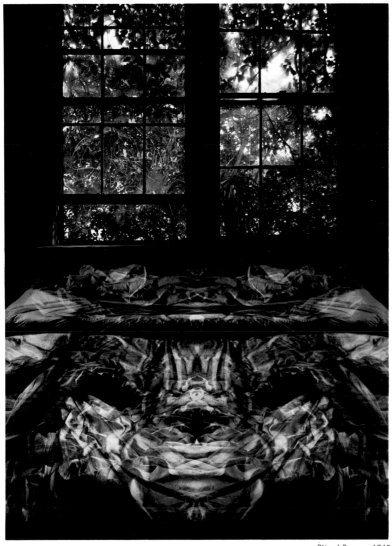

Ritual Room 1965

name. The sun annoys the woman that it should search the room
 everyday lighting the wall where he had cursed his shadow. The sun
comes everyday because it has become used to coming through a window
 where it rests safely in its golden gloom. The vain sunlight lying on the
floor sunning itself, a yellow kitten made of dust. He had not liked
 old persons who had become more memory than flesh sitting in
 the sun like peopleless shadows.

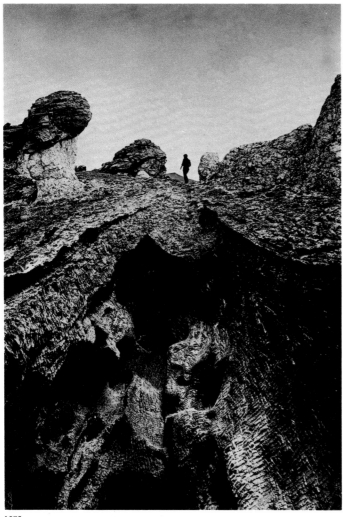

1972

MR BRAIN

Mr Brain was a hermit dwarf
who liked to eat shellfish
off the moon.
He liked to go into a tree
then because there is a little height
to see a little further,
which may reveal now the stone,
a pebble—it is a twig,
it is nothing under the moon
that you can make sure of.

So Mr Brain opened his mouth
to let a moonbeam into his head.

Why to be alone,
and you invite the stars to tea.
A cup of tea drinks
a luminous guest.

In the winter could you sit
quietly by the window, in the evening
when you could have vinegar
and pretend it to be wine,

because you would do well to eat doughnuts

and pretend you drink wine

as you sit quietly by the window.

You may kick your leg

back and forth.

You may have a tendency

to not want to look there too long

and turn to find darkness

in the room because

it had become nighttime.

Why to be alone.

You are pretty are you not/ you are

as pretty as you are not,

or does that make sense.

You are not pretty,

that is how you can be alone.

And then you are

pretty like fungus and alga,

you are no one without some one,

in theory alone.

Be good enough to go to bed

so you can not think too much longer.

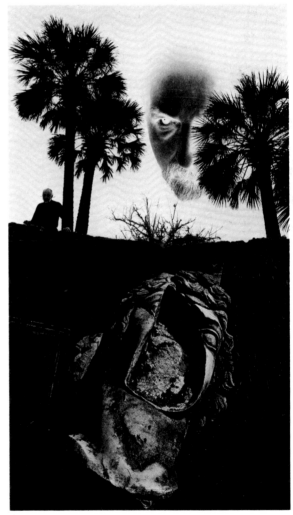

1969

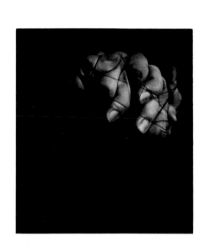
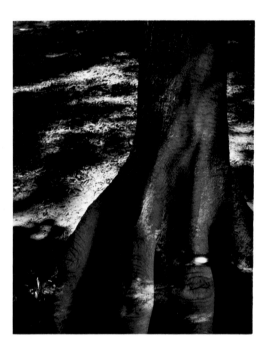
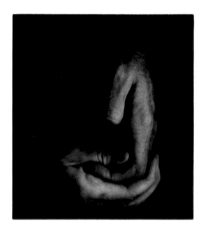

On Marriage 1961

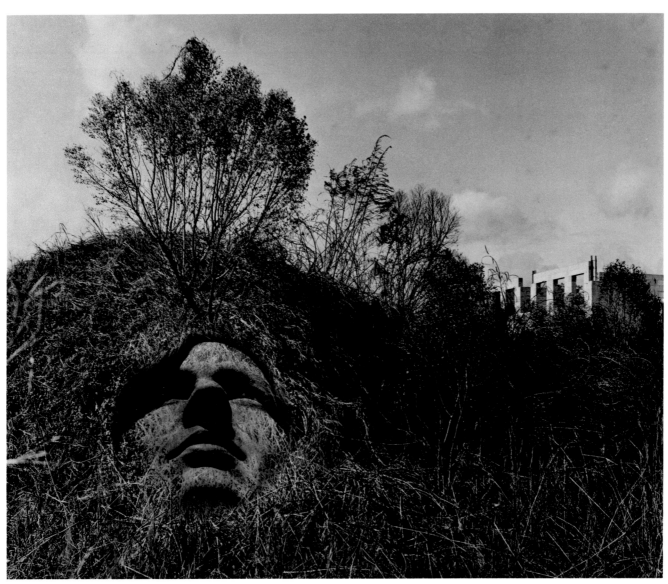

Allegorical Landscape 1963

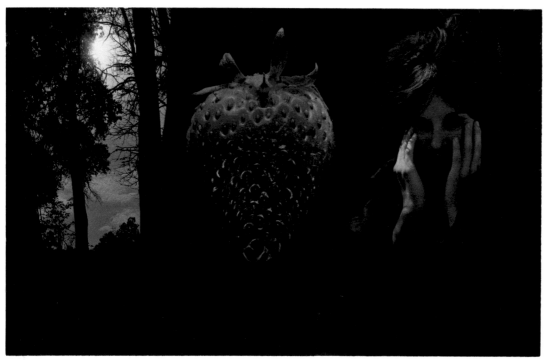

Strawberry Day 1967

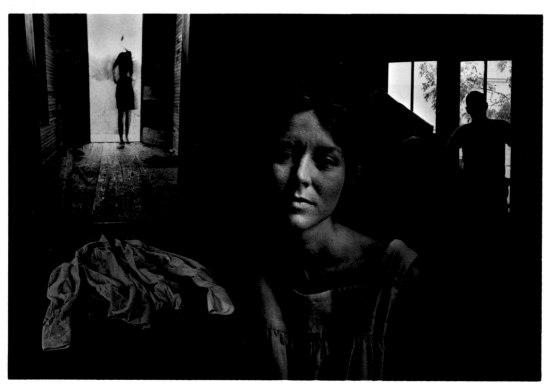

Room #1 1963

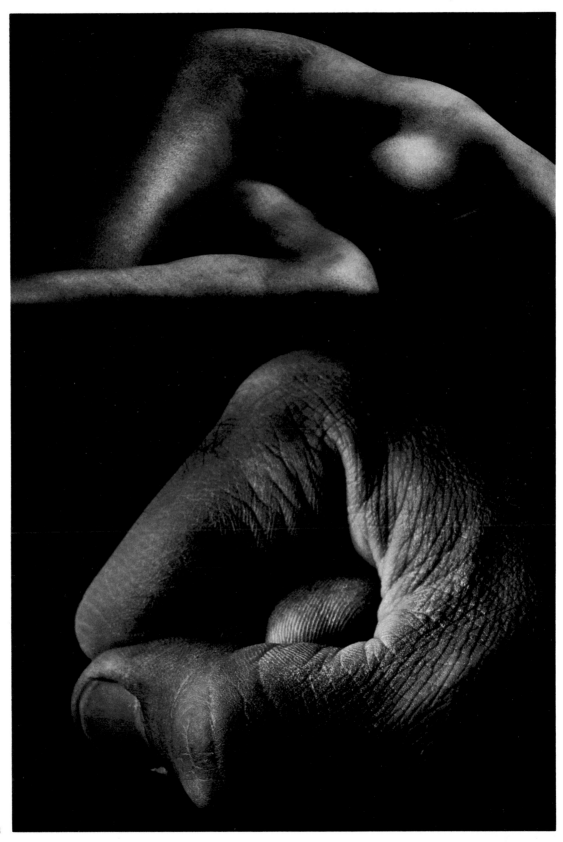

Equivalent 1964

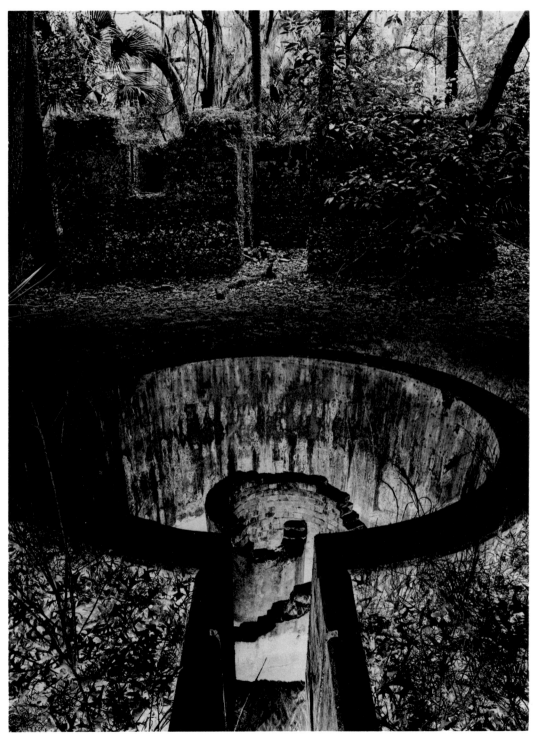

Ritual Ground 1964

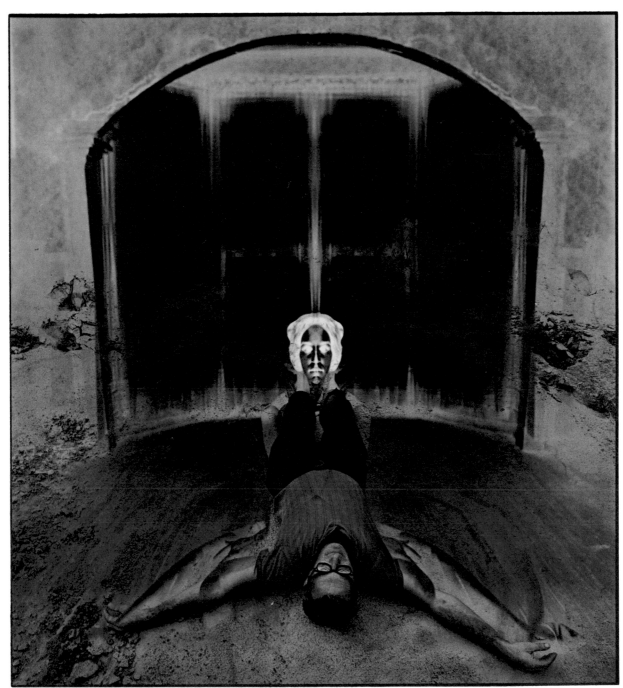

1968

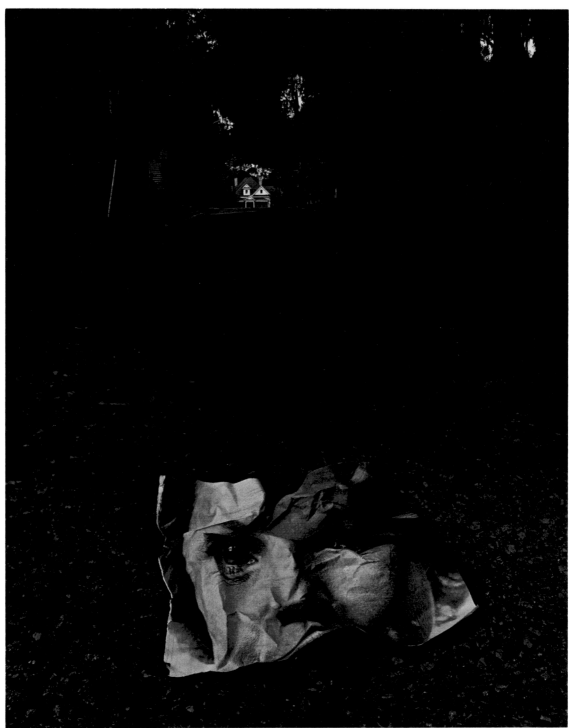

Home Is a Memory 1963

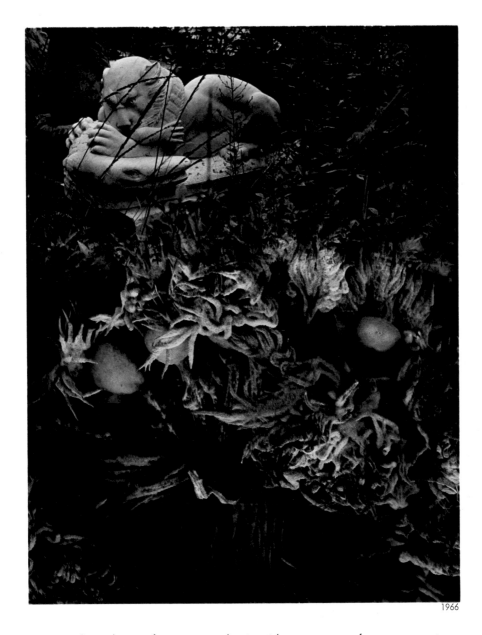

1966

THIS THAT IS *At night in a forest one who is without name or face tears out*

his own brain to remember what it is he forgets. One who is without name

or face runs through the night with his empty head filled with

emptiness. An old woman seeing this that runs holds a stick across the forest

road to see how it falls. One who is without name or face falls and says,

I am that that falls and now memory begins to smack its lips. Come,

says the old woman, into my place of candle light.

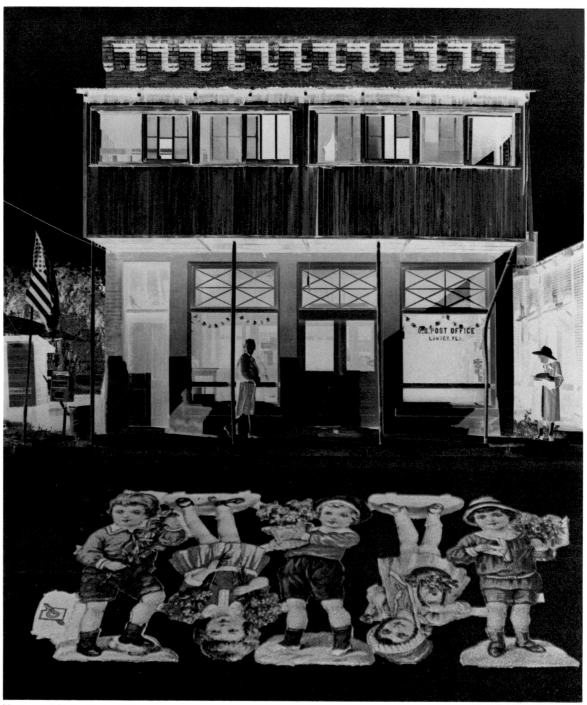

Massacre of the Innocents 1964

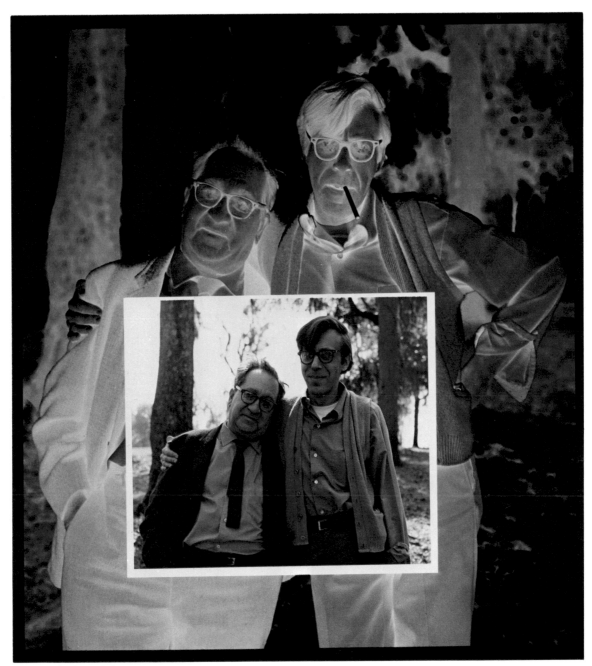

Aaron and Nathan 1969

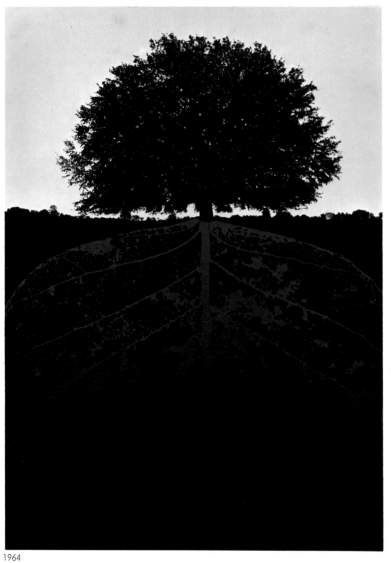

1964

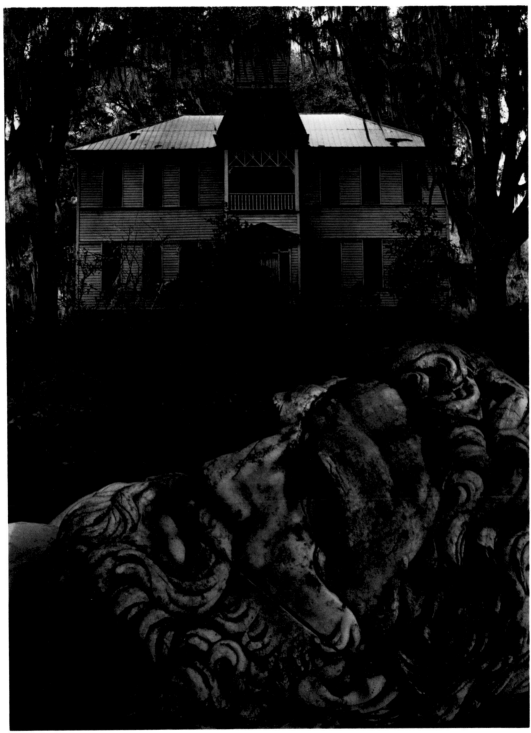

1964

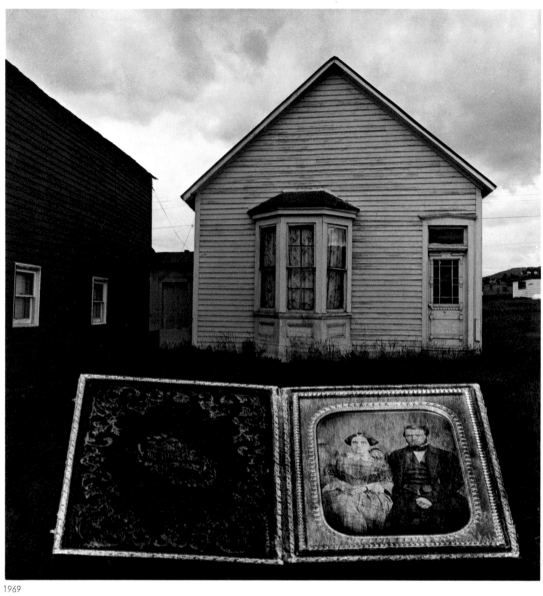

1969

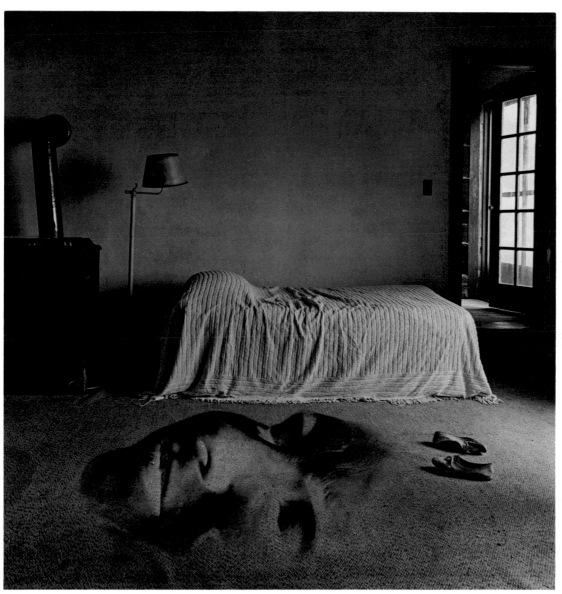

1968

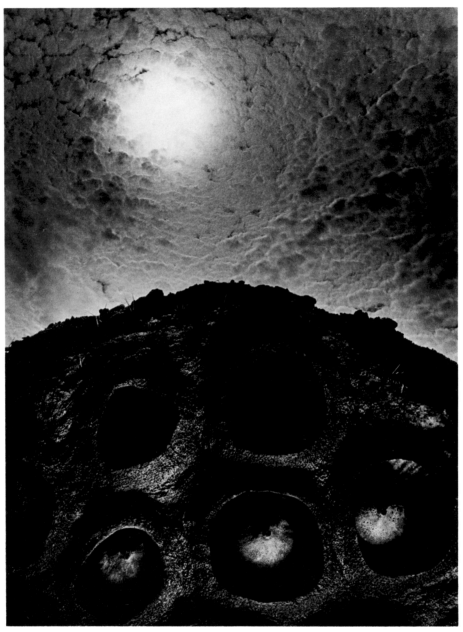

1964

CLOUDS

A husband and wife climbed

to the roof of their house,

and each at the extremes of the ridge

stood facing the other

the while that the clouds took

to form and reform.

The husband said,

shall we do backward dives,

and into windows floating

come kissing in a central room?

I am standing on the bottom

of an overturned boat,

said the wife.

The husband said,

shall I somersault along the ridge of the roof

and up your legs

and through your dress out of the neck

of your dress to kiss you?

I am a roof statue

on a temple in an archaeologist's dream,

said the wife.

The husband said, let us go down now

and do what it is

to make another come into the world.

Look, said the wife,

the eternal clouds.

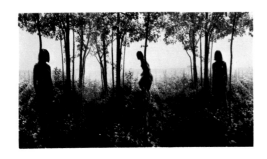

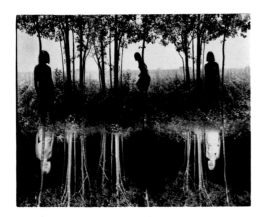

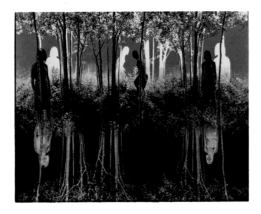

THE TURNING OFF OF LIGHT

Let us say a man holding a cup of coffee

like a lantern journeys a road

with a white figure

in parallel personifying light.

They come to a fork,

the white figure taking the left

or is it the right,

but the man taking the opposite,

and that is

the turning off of light.

The coffee cup a lantern

but not a lantern of light,

it illuminates without light.

Don't you see sir,

the lighting of the nerves,

that fuel of hell.

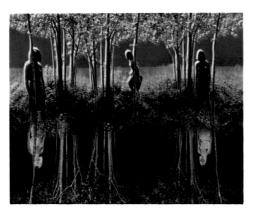

Small Woods Where I Met Myself 1967

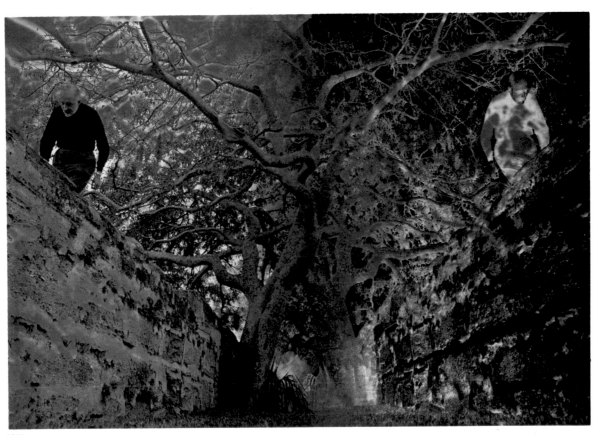

1967

VEGETABLES

At the green grocers a man
had bought a monstrous vegetable.

He had said to the grocer,
I will give you a punch in the nose
for that green earth child.

No no, the earth is full enough
of tears, said the grocer.

Well, may I just take it home
and chew it to death?
said the man.

Look out, said the grocer,
a tomato is watching you;
and I think a celery would love
to break your back.

It would,
and maybe a certain green grocer

would like me to lift his apron
and let the public see his bowed legs?
said the man.

If you do maybe I'll turn a doorknob
and a door will open, said the grocer.

Well, maybe I'll tell the grapes
your bellybutton's on your left thumb,
said the man.

Oh yeah,
well maybe I'll turn around
and wait on another customer,
said the grocer.

Oh please, Mr. green grocer
let me have something green to kill.

Well take this, screamed the grocer.

But when the man got home
with his monstrous vegetable
his wife said, the grocer has cheated you,
this is your son.

FAREWELL TO A MOUSE

One who leaves his home
in projection through a thought
remembers the small mouse of the wall,
whom he has never met
more than the small nods of recognition
exchanged between them when
entering the kitchen, as it were,
when hunger moved them both
at the same time.

He that is leaving,
and remembering the small mouse,
decides to write a farewell
to the mouse
whom he has never met
more than the slight smiles
given in haste when passing
each other in the hall
on the way to the bathroom,
or the linen closet, or going up to the attic
for a short melancholy stay

in which an old piece of lace
might be fingered,
or an old photograph again newly stained
by a sudden overflowing
of the tear ducts.

What can you say to a dear friend
whom you have never met?
Can you say
I have loved you from afar?
Would that seem somehow sexual?

But, in the heart is a mousetrap,
which now begins to move
down the arms,
emerging out of the palm
of the left hand.
It is a real mousetrap,
Heaven knows where it has come from.

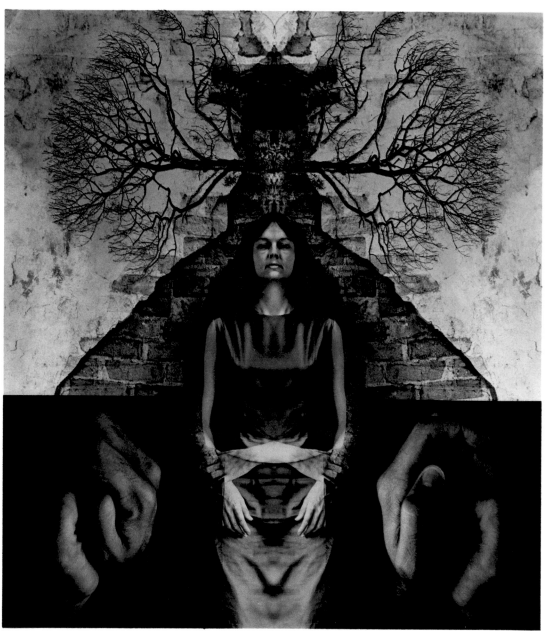

1968

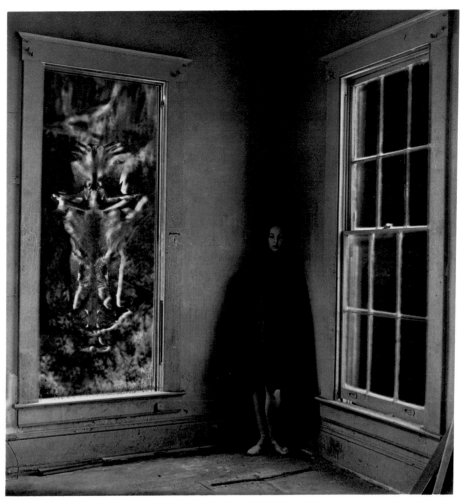

Night Fears 1968.

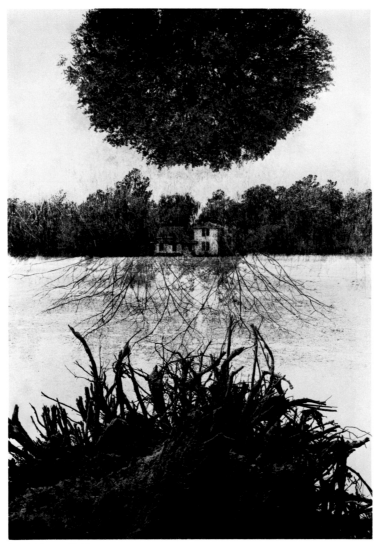

Poet's House 1965

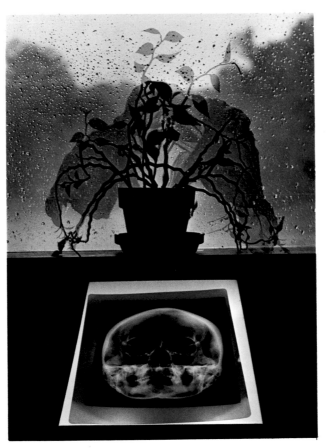

1969

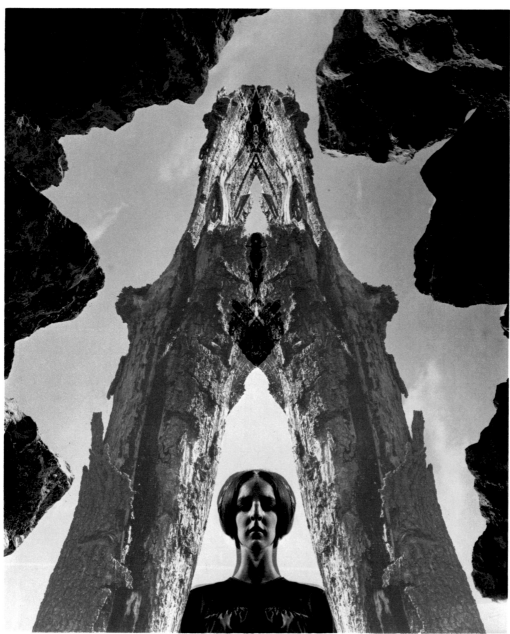

1966

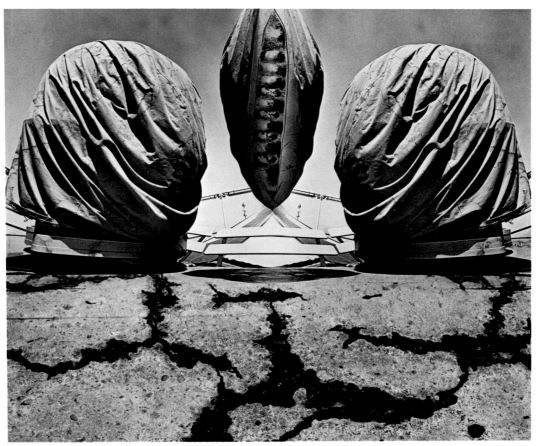

1968

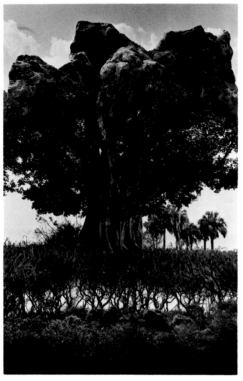

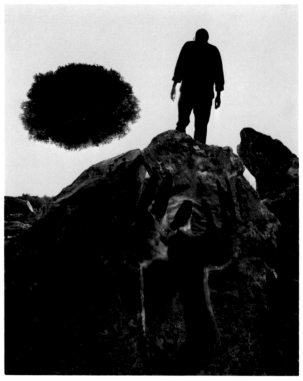

Rock Tree 1969

1967

THE YOUNG BOAT

We set out in a young boat,
 whose bones had not
fully come from cartilage.
 Wisdom was yet to divide
the softness
 from the softness.
 What shall we do as we seek a land
 in a boat with a rudder
as vague as a baby's hand?

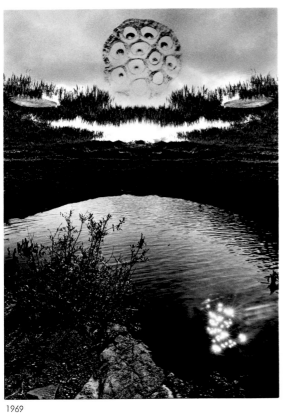

1969

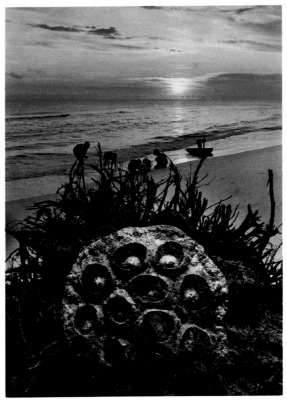

1968

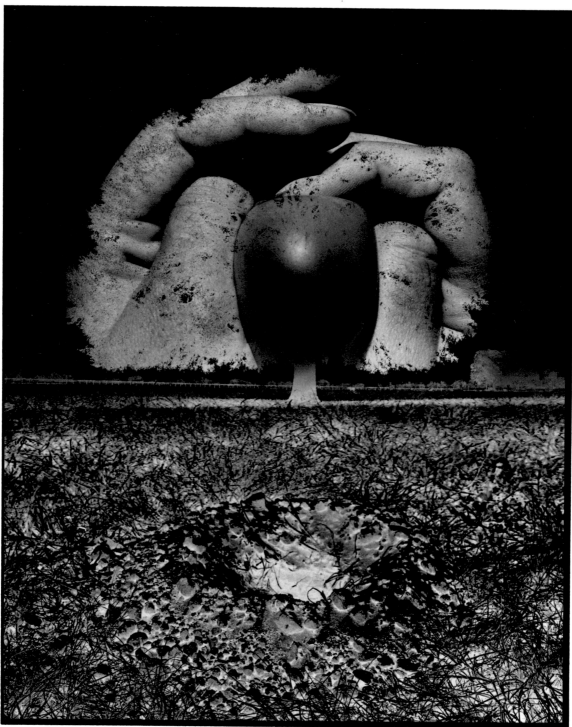

1968

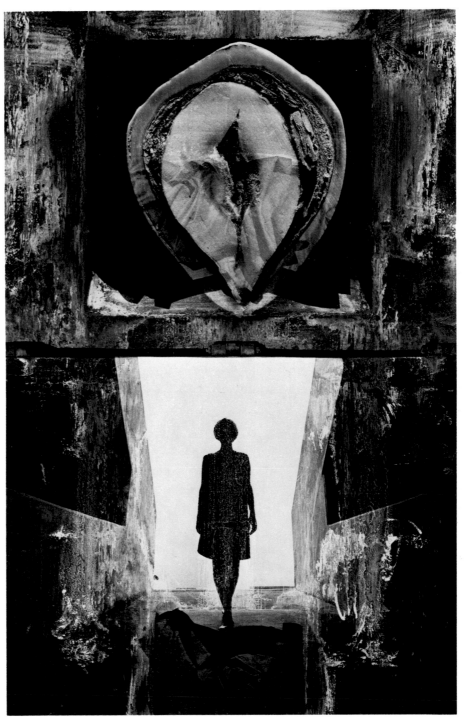

1968

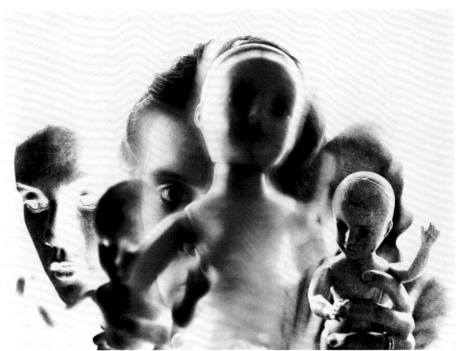

Riddle of Innocence 1967

WHEN SOMETHING IS BROKEN

When something is broken, you cannot fix it.
You have taken a hammer to it, but you cannot fix it.
You have banged and banged, and still it is not fixed.
You have tried to mend it with your tears,
but they are not thick enough.
You have tried again with the hammer,

and broken it only further.
Was it then that the authority
removed you from your difficulty
and broke you in the house of understanding?
It is from the window, there with your back to the room,
looking out that you know that tears cannot mend;
no matter how intent or tender, tears are not enough....

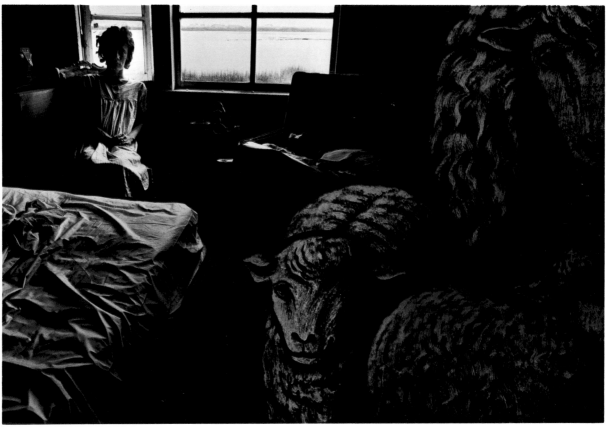

Marilynn and the Sheep 1964

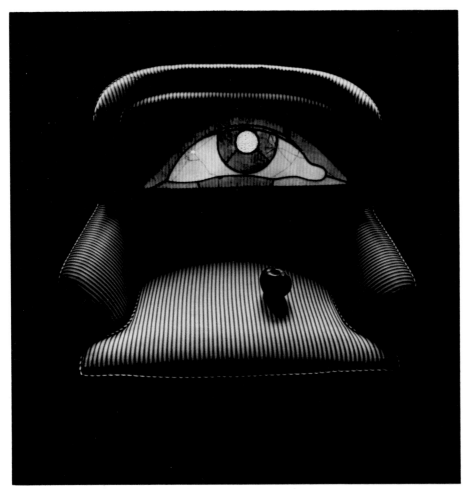

Eye Chair 1969

A CHAIR

A chair has waited such a long time to be with its

person. Through shadow and fly buzz and the floating

dust it has waited such a long time to be with its person.

What it remembers of the forest it forgets, and

dreams of a room where it waits—Of the cup and the

ceiling—Of the Animate One.

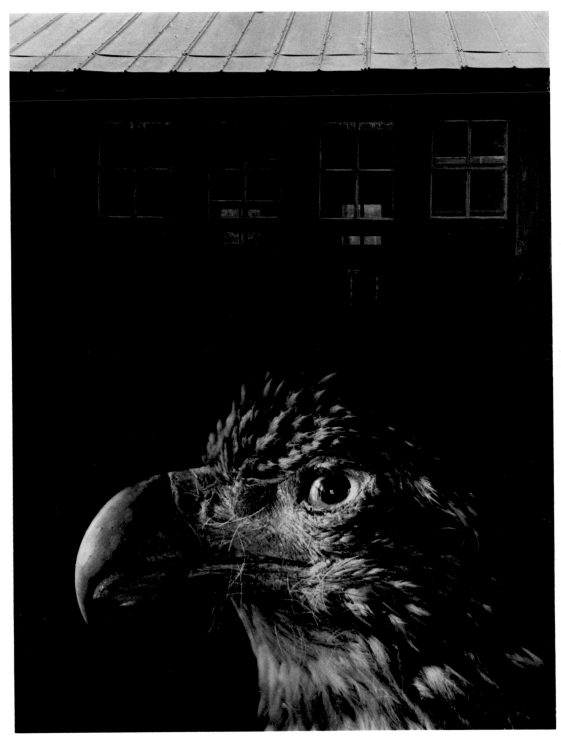

Bless Our Home and Eagle 1962

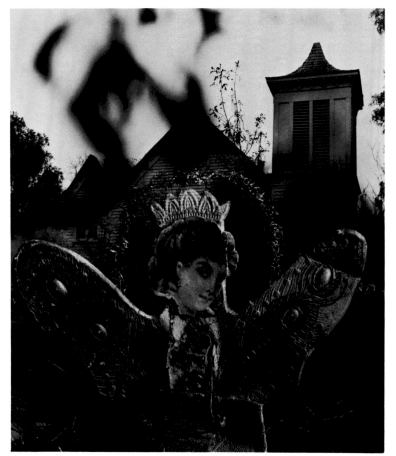

My Angel 1964

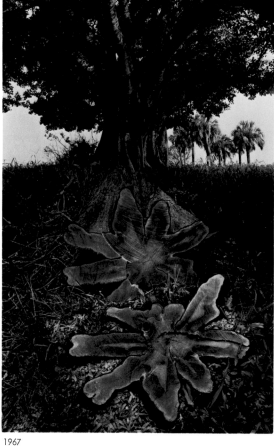

1967

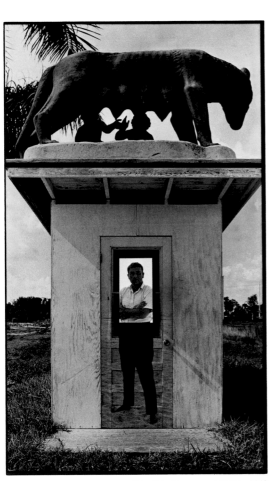

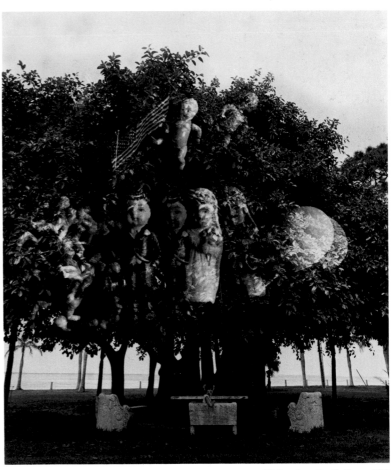

Romulus, Remus, and Peter 1968

All American Family Tree 1965

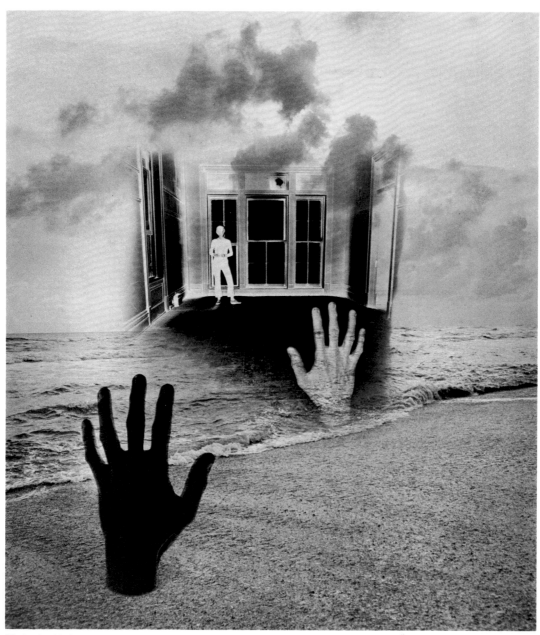

Navigation Without Numbers 1971

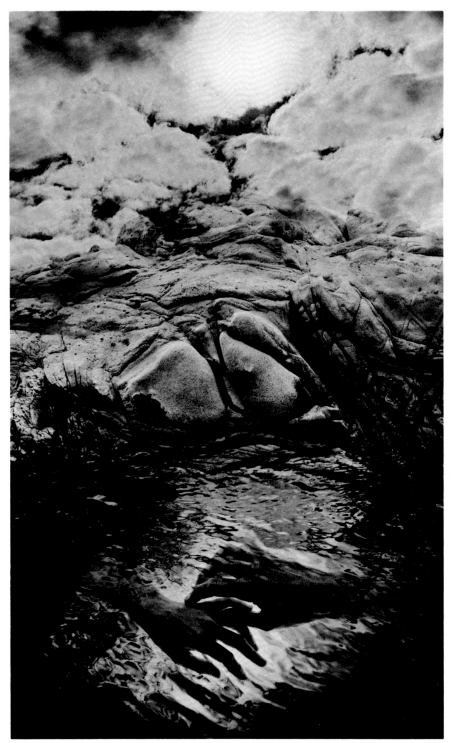

1972

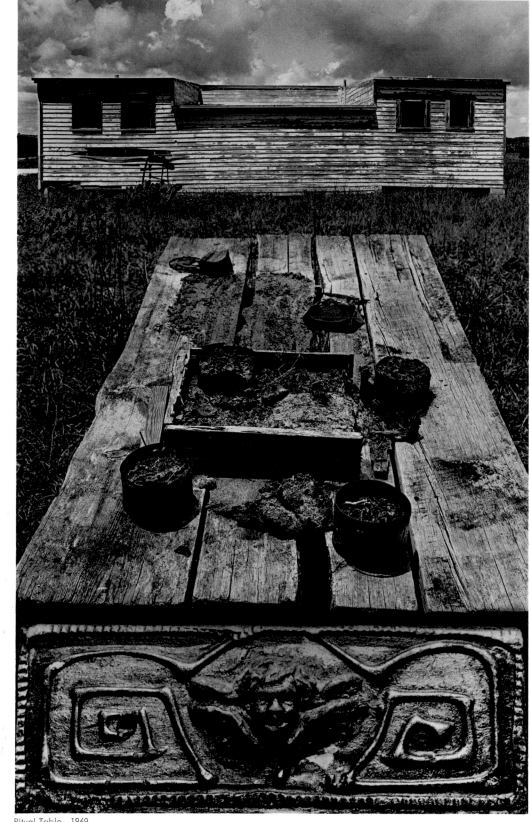

Ritual Table 1969

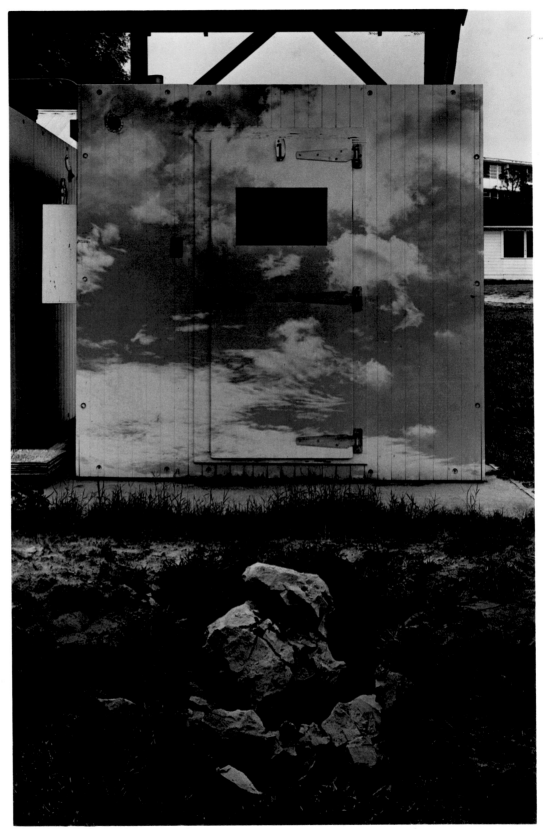

Sky House 1967

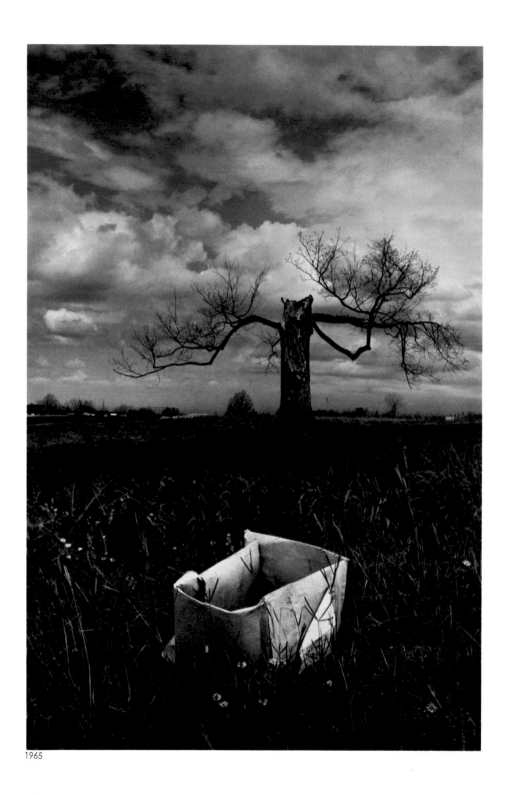

1965

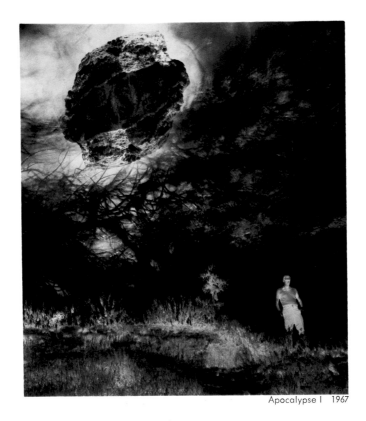

Apocalypse I 1967

THE MAN ROCK

*A man is a rock in a garden of chairs and waits for a
longtime to be over.*

*It is easier for a rock in a garden than a man inside his mother.
He decided to be a rock when he got outside.*

A rock asks only what is a rock.

A rock waits to be a rock.

*A rock is a longtime waiting for a longtime to be over so that
it may turn and go the other way.*

*A rock awakens into a man. A man looks. A man sleeps back
into a rock as it is better for a rock in a garden than a man
inside himself trembling in red darkness.*

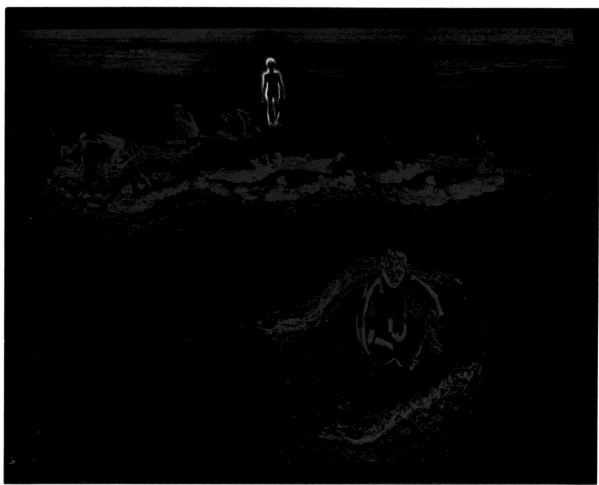

1969

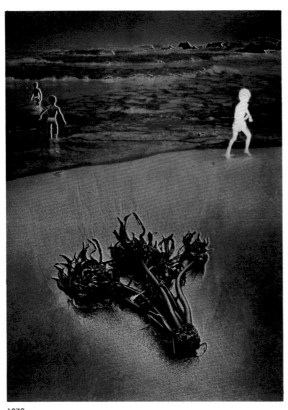

1972

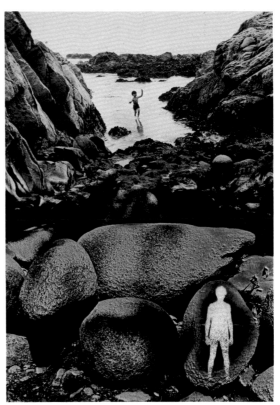

1972

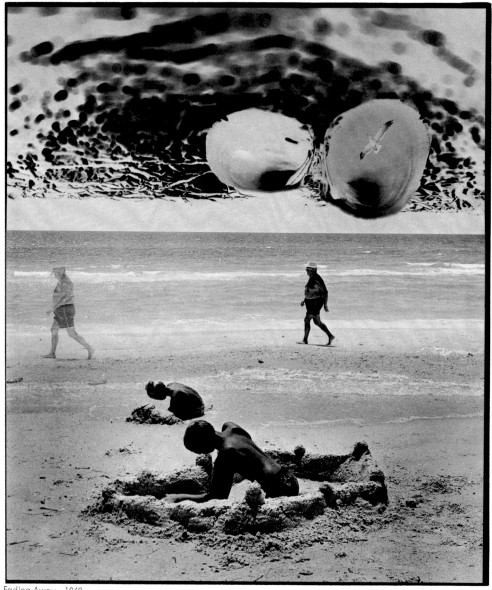

Fading Away 1969

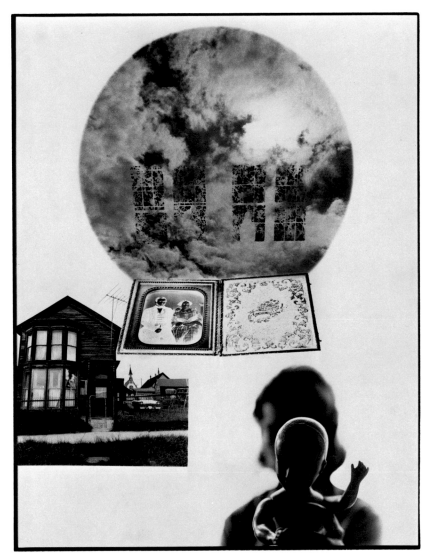

Forgotten Heritage 1969

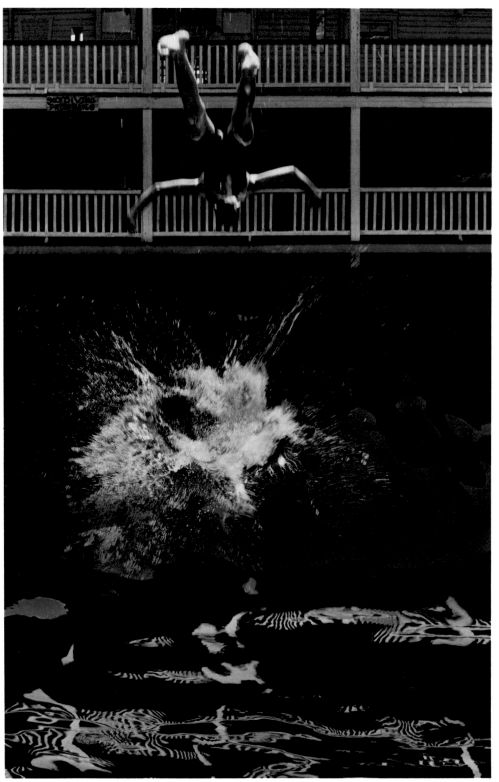

The Dive 1967

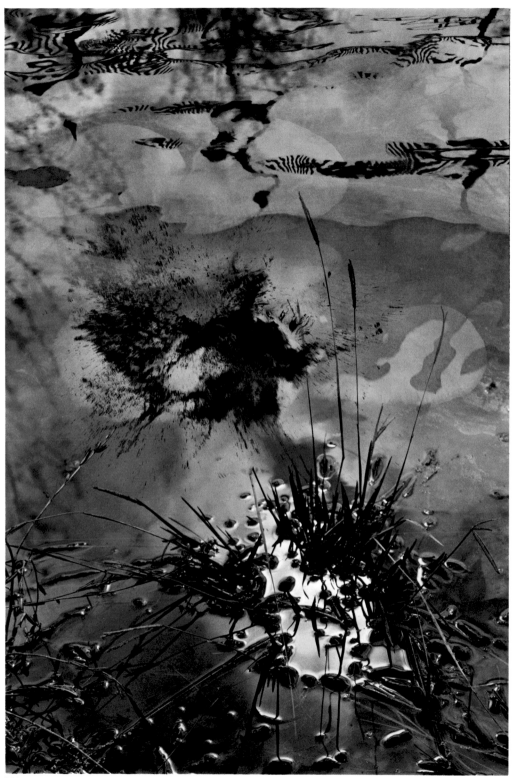

1967

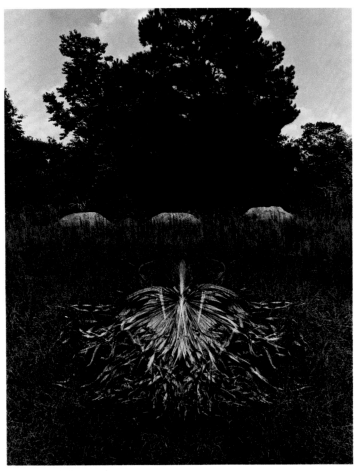

Simultaneous Intimations 1965

THE ARTIFACT

Someplace is hidden because there is no one there
—Where a leaf and a stone has eyes, with a twig as nose, and
a squirrel's skeleton a mouth of teeth: look for a time up
through the trees at the changing sky.
The wind blows a leaf away, one eye closes.
Someplace hidden because no one is there looks out
of itself at the universe.

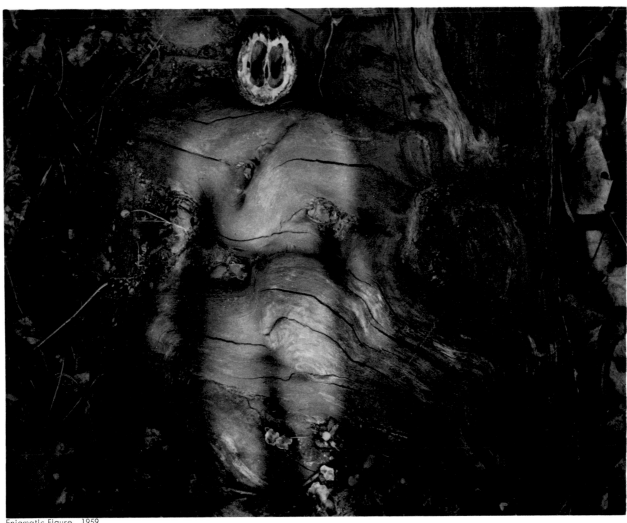

Enigmatic Figure 1959

THE NEED

If you talk to a cloud it listens that it does not turn from

you. But it changes, the borders of its attention melt out

like an aging parent into facsimile shapes.

If you talk to a cloud you talk only that you talk;

that there is aim to the persuasion; that the force of the

need as voice has ear.

If you talk to a cloud you talk to yourself, for you

have need to talk for you have need.

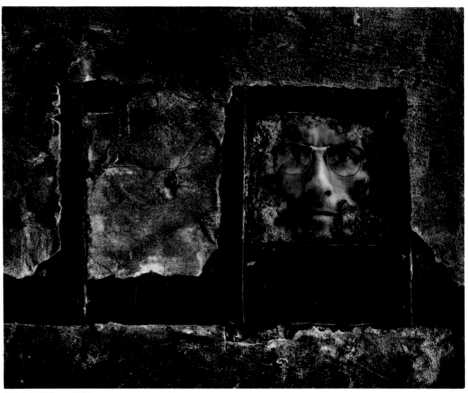

Restricted Man 1962

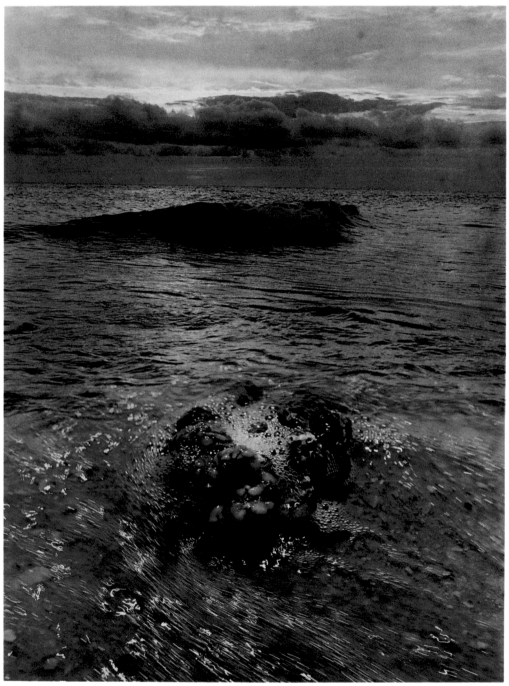

1969

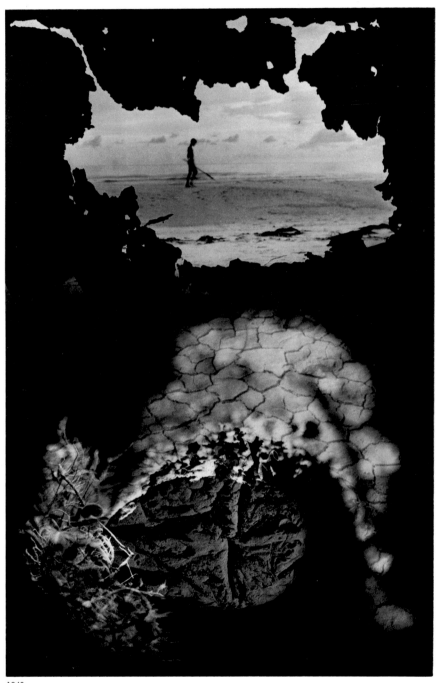

1968

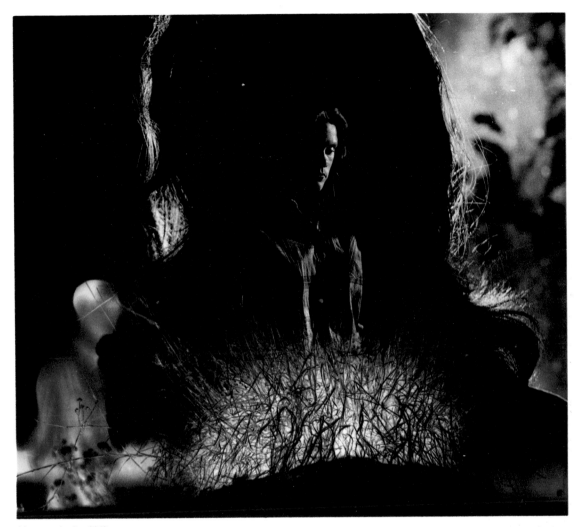

Metamorphosis 1962

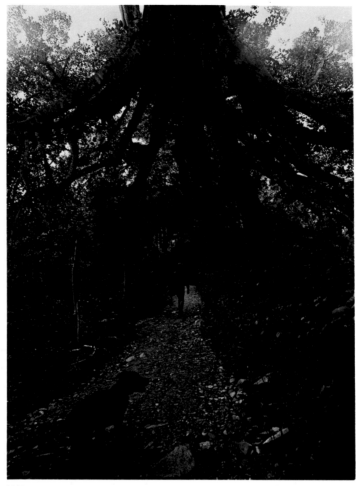

1969

A VALLEY

Between mountains a man is well acquainted

with desire. He cannot live here like a secret,

desiring and desired. He lives here, as all do.

Soon the difficulty dies with the man.

But until it does it is not made

less because we know the end.

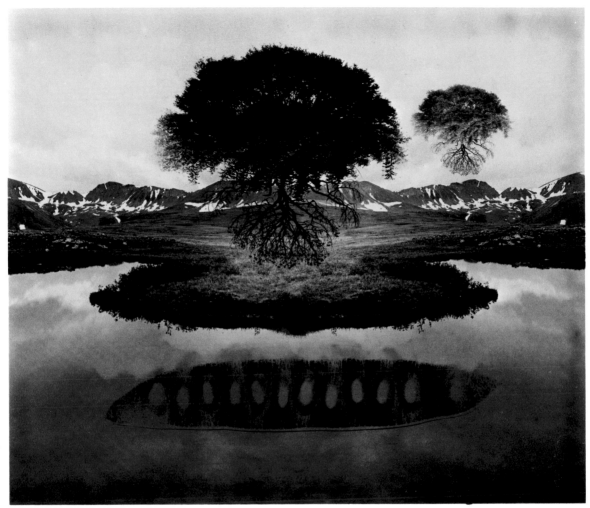

1969

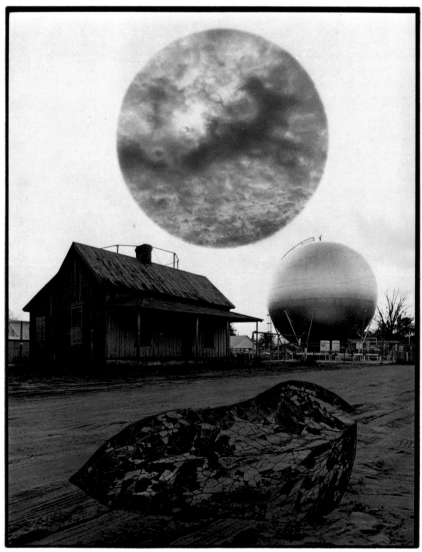

Apocalypse III 1969

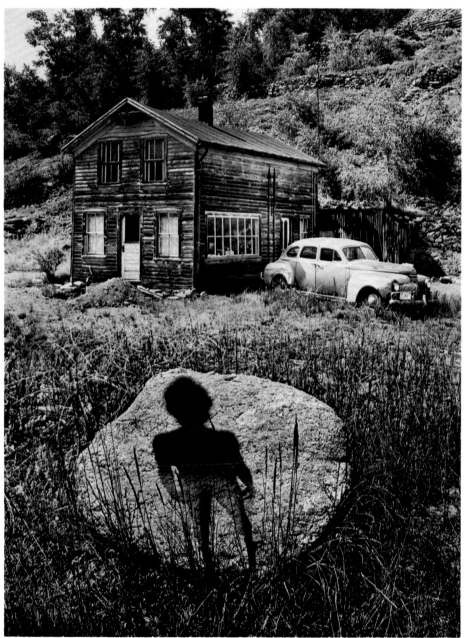

1971

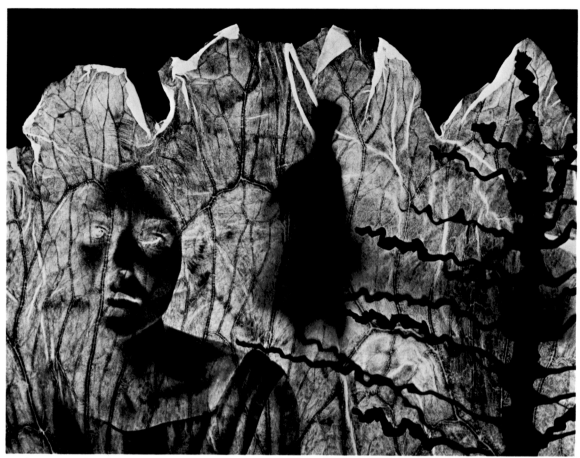

Conjecture of a Time 1964

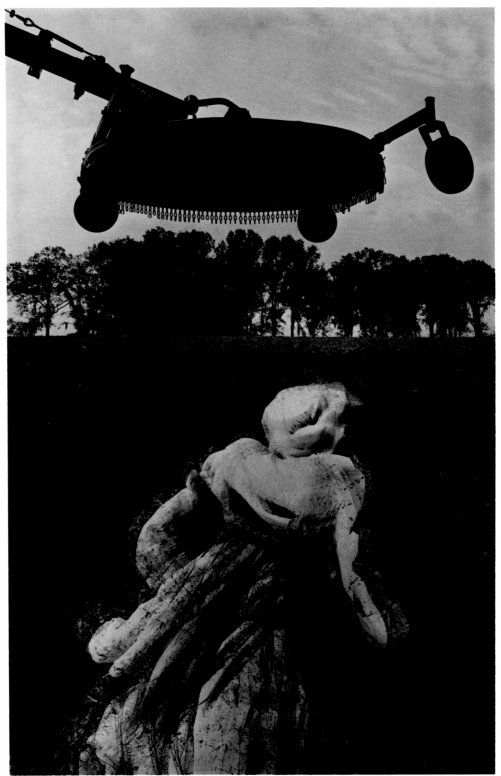

1968

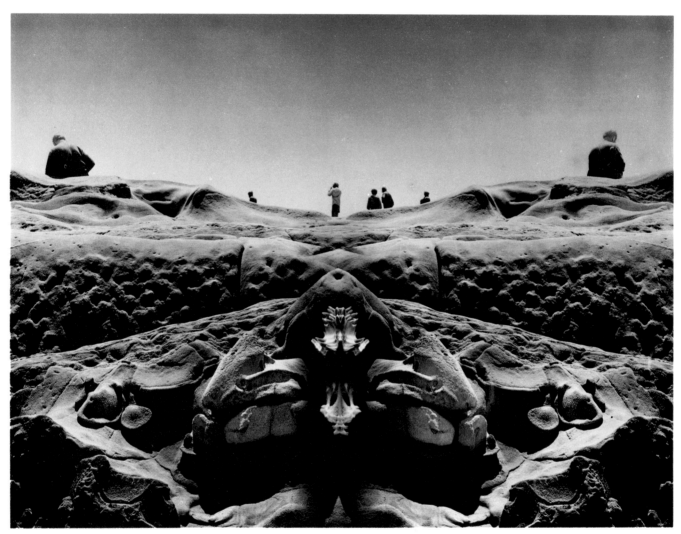

Point Lobos 1969

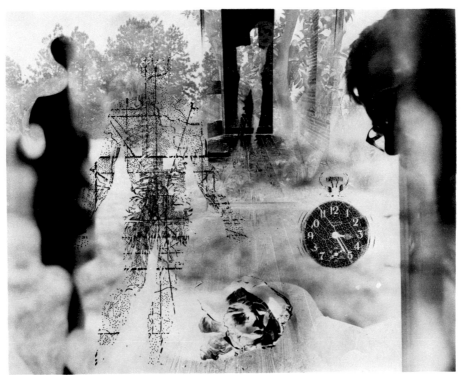

In Search of a Cause 1966

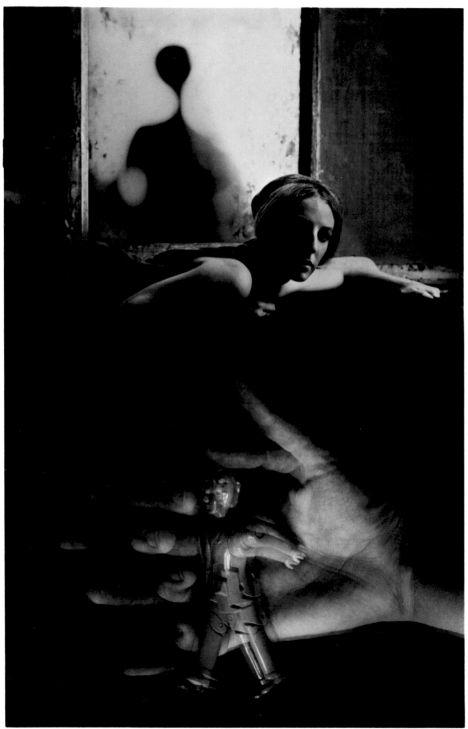

Free But Securely Held 1965

THE SUICIDE

After I heard about murder I said
to a door you may rest in your sill,
and so I closed it and drew the shades
on the windows.

It was a wooden box I lived in
because I knew someone was hurt.
I let no light of any moon or sun come in
because someone dies
by the hand of man
without the intervention of God.

I shut my eyes and held my ears
because someone is badly used.
I closed my mind with sleeping pills.
I murdered myself
that I might shut out the murder of others.

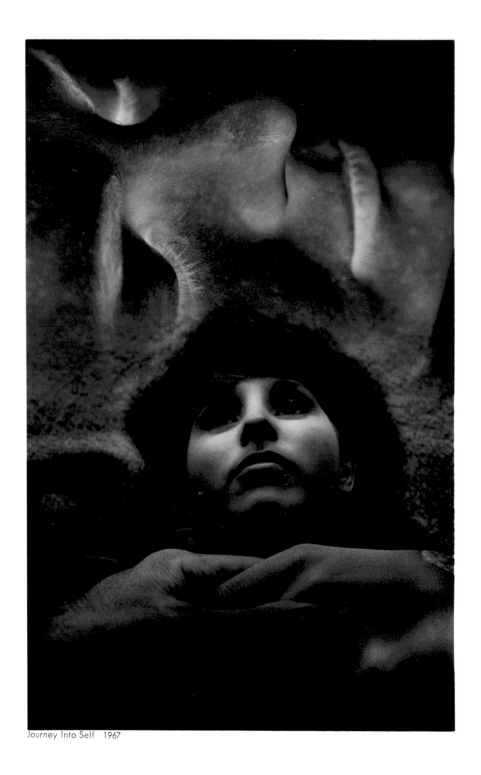

Journey Into Self 1967

THE EMPTINESS

As he was alone he sat on a chair.

No use standing with open arms.

Only the wind comes

and will not be held.

On a bad day the wind

will knock you down

and run right over you

to further pleasures.

When alone one describes

one step of a stairway,

and sitting there describes

till late at night

under those high things

that glow in the sky;

with much wonder about the structure

of the eye.

Till again one must put oneself to bed

to close out the emptiness.

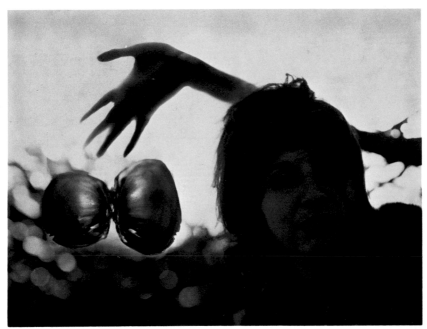

A Moment I Do Not Remember 1967

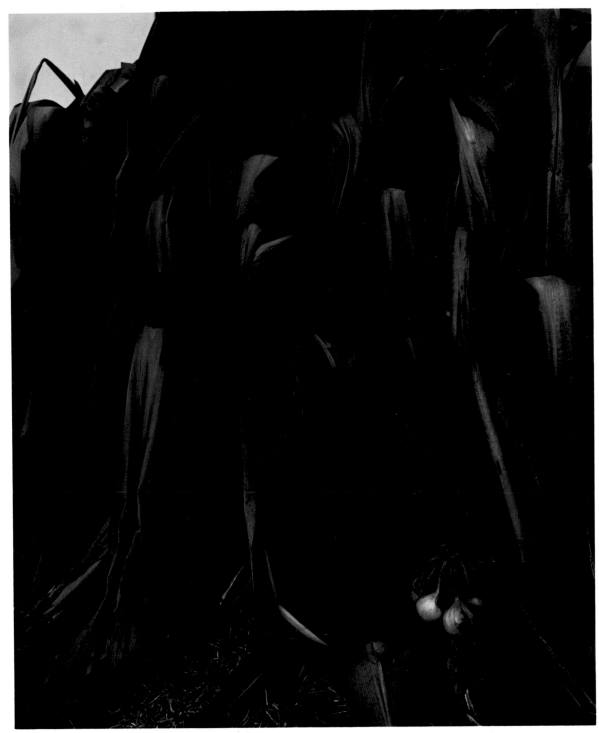

1961

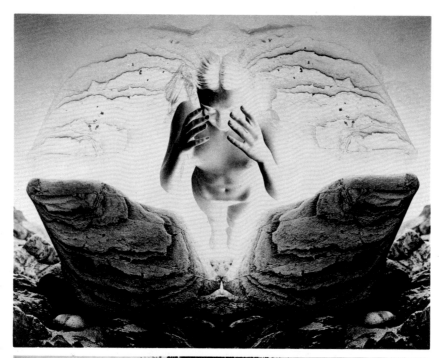

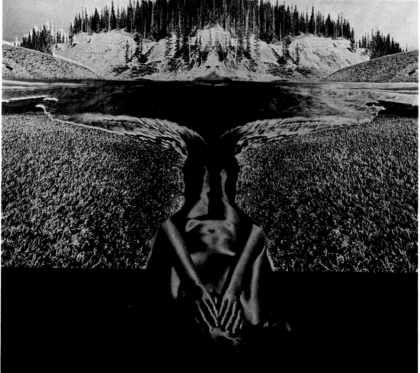

1972

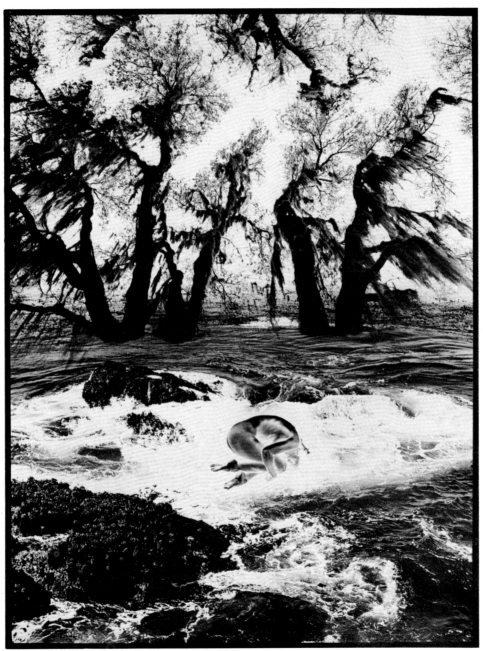

1971

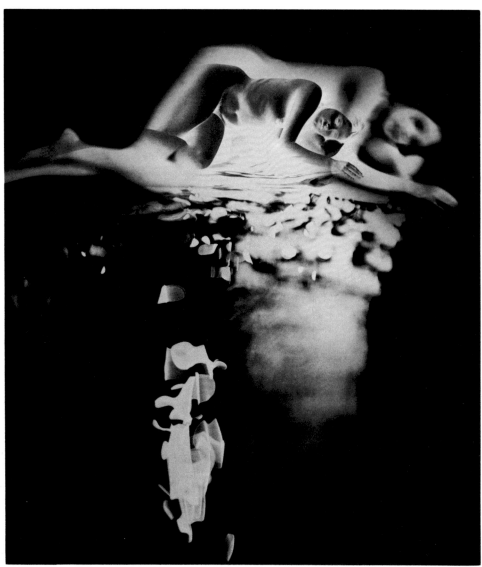

1972

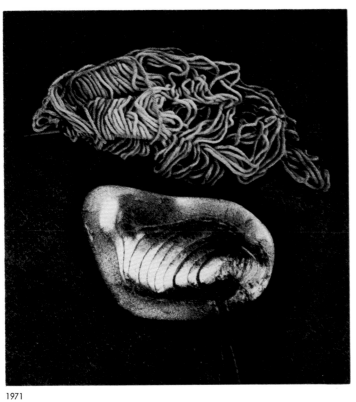

1971

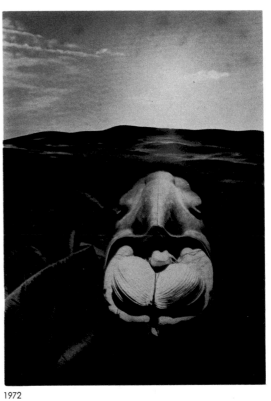

1972

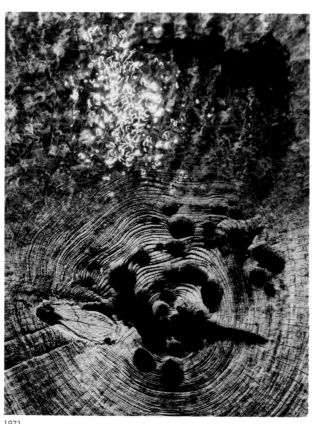

1971

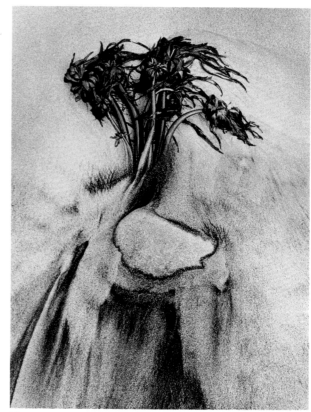

1971

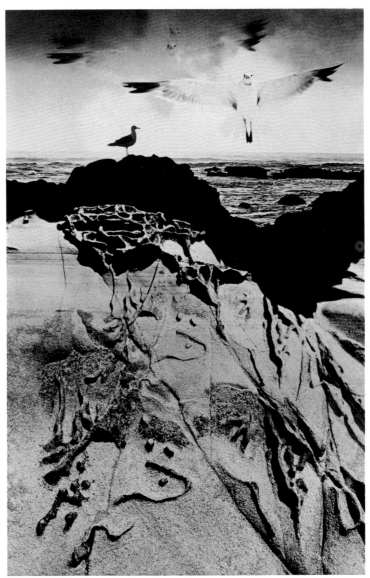

1970

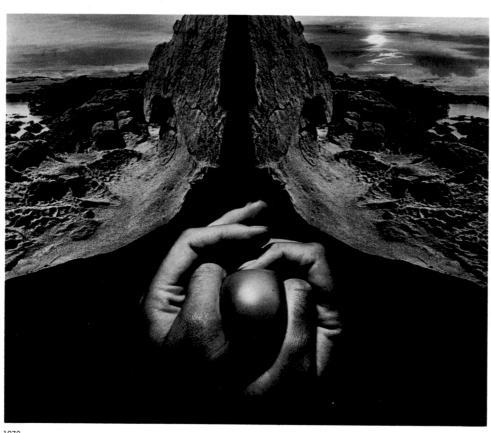

1970

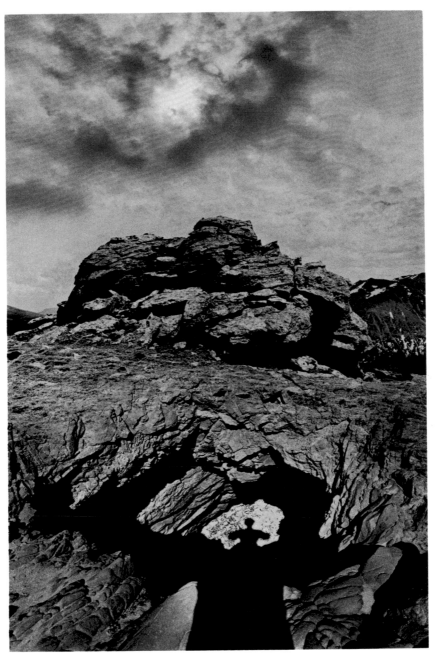

1972

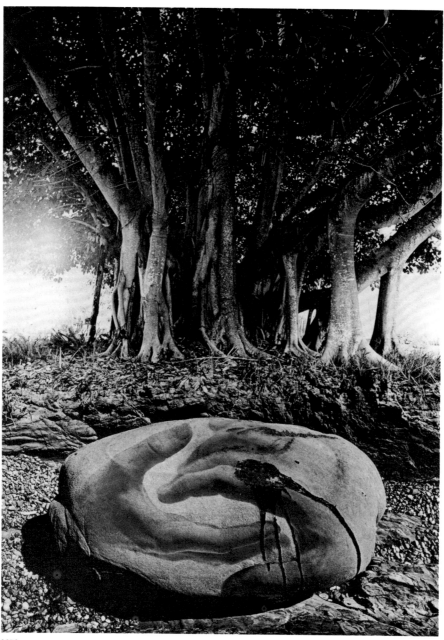

1970

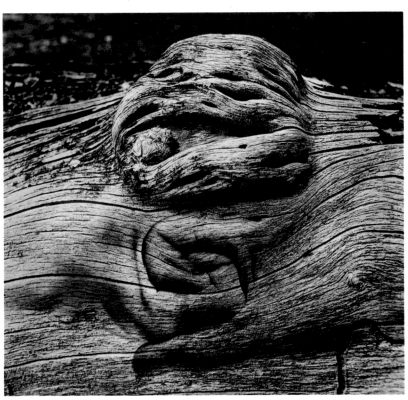

1970

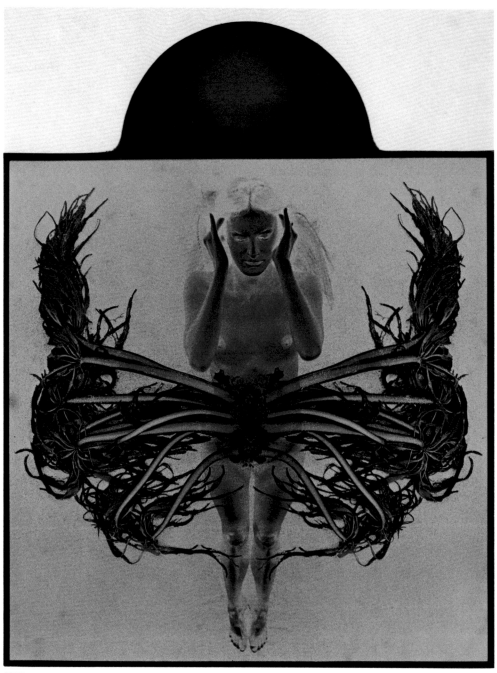

1972

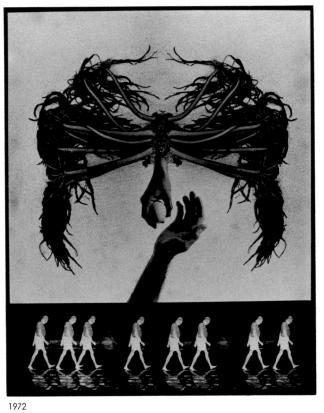

1972

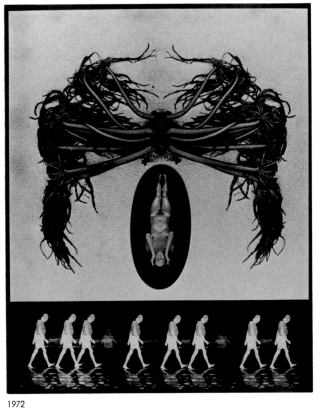

1972

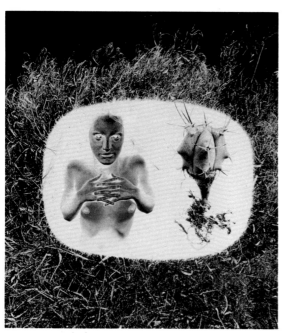

1971

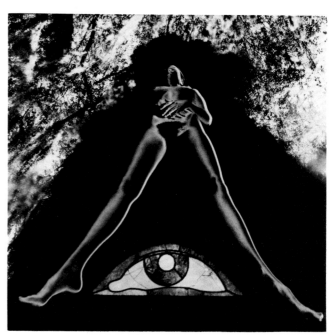

1972

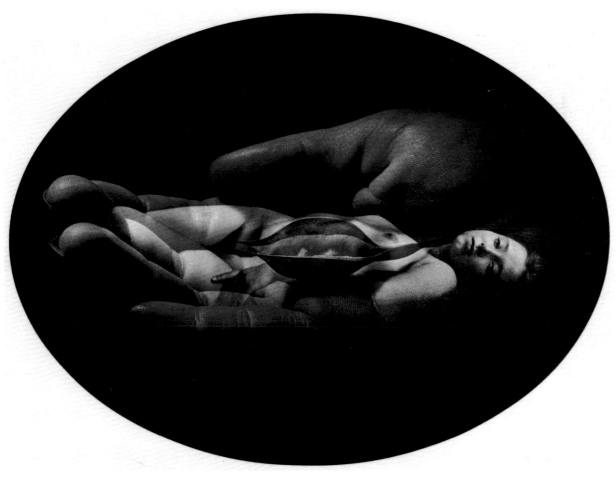

1972

Bill Everson 1972

Jack Welpott 1972

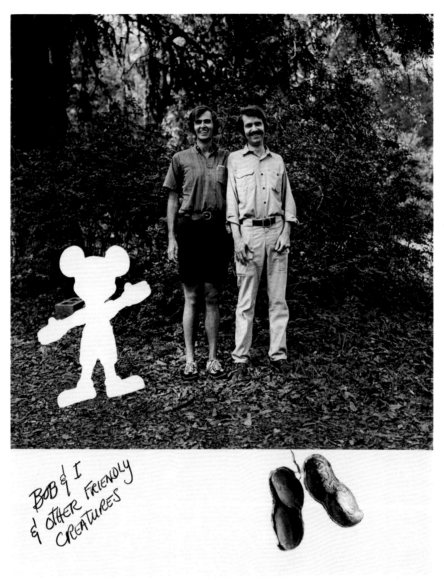

BOB & I
& OTHER FRIENDLY
CREATURES

1971

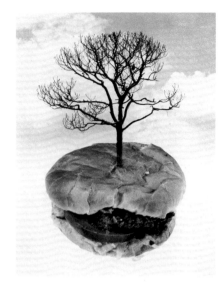

Little Hamburger Tree 1970

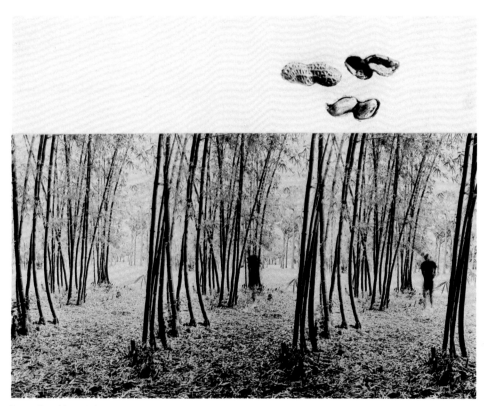

Peanut Parable 1970

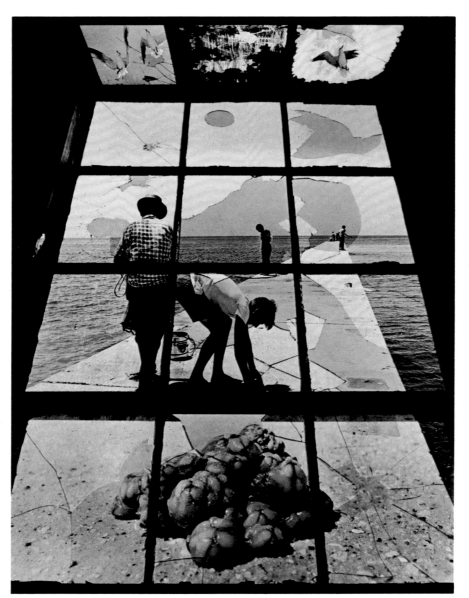

1970

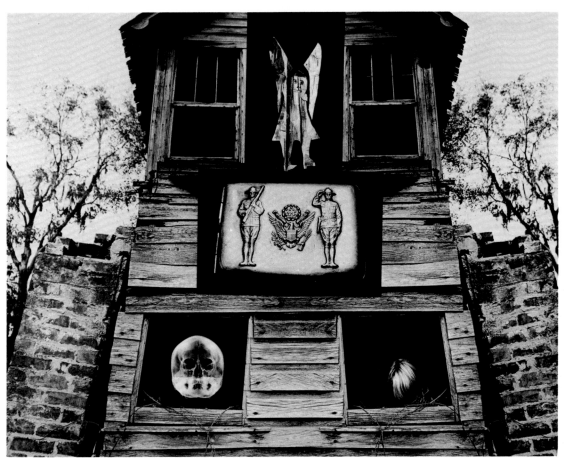

War Shrine 1970

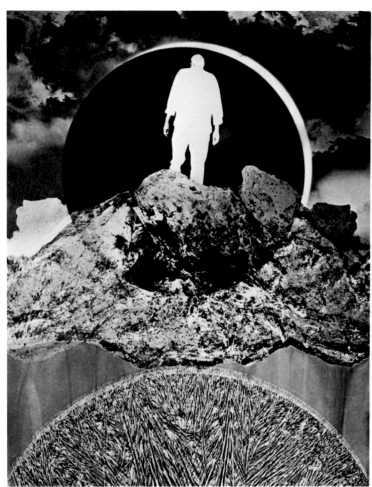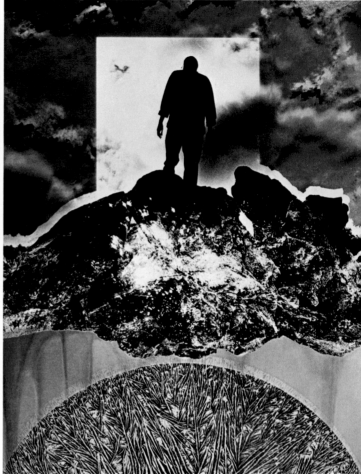

Two Paths of Life 1969

CHRONOLOGY

1934 Born in Detroit, Jerry Norman Uelsmann, second son of Mr. and Mrs. Norman Uelsmann. The father is an independent grocer. Attends public schools; indifferent student.

1950 While in high school develops, in part from father's and brother's hobby, a typical vocational interest in photography.

1953 Enters Rochester Institute of Technology in its first four-year degree program in photography. Deeply influenced and encouraged by Ralph Hattersley and also by Minor White, both on the faculty. Limited contact with the George Eastman House.

1957 Receives B.F.A. degree. Marries Marilynn Kamischke of Detroit. First published photograph in *Photography Annual 1957*.

1957-58 Enters Indiana University Graduate School, Bloomington, in audio-visual communications; continuation of a vocational interest in the medium. Serves as graduate assistant in laboratory. Graduates with M.S. degree but disillusioned with the field.

1958-60 Transfers to the Department off Art, Indiana University Graduate School. Henry Holmes Smith, a faculty member, highly influential as a *provocateur* and in coalescing the realization of photography's potential as a crea-

tive medium. Considers Hattersley, White, and Smith to be primary photographic influences. Laboratory assistantship continues. Intensive study in art history, also studies in design. With Jack Welpott, a fellow graduate student, completes five programs on photography for local educational television station. Graduates with M.F.A. degree.

1960 Interim Instructor, Department of Art, University of Florida, Gainesville. Van Deren Coke also on the faculty.

1962 Instructor, University of Florida. Founding member of The Society for Photographic Education; delivers paper, "The Interrelationship of Image and Technique," to that body in Rochester. First group exhibition with substantial representation, "Three Photographers," George Eastman House. Selected for "New Talent USA," *Art in America.* Multiple printing now an integral part of visual vocabulary, although isolated examples appear earlier.

1963 First major one-man exhibition (103 photographs) at the Jacksonville Art Museum, Jacksonville, Florida.

1964 Assistant Professor of Art, University of Florida. Exhibits with the Association of Heliographers in New York. First important portfolio and essay on his work, with picture selection and layout by himself, in *Contemporary Photographer.*

1965 Second paper, "Post-visualization," delivered to The Society for Photographic Education in Chicago. Sees first floating tree. Completes building an architect-designed home in Gainesville; upon occupancy acquires first darkroom of his own (prior to this date relied on various university facilities for all personal photography). This date marks the beginning of his individual realization of the "darkroom as a visual research lab." Begins with two enlargers (four at present) and gradually acquires additional equipment.

1966 Associate Professor of Art, University of Florida. Elected to the Board of Directors, The Society for Photographic Education.

1967 One-man exhibition at The Museum of Modern Art, directed by John Szarkowski. On third application, awarded a Guggenheim Fellowship for "Experiments in Multiple Printing Techniques in Photography." Remains in Gainesville during fellowship period. Featured on national educational television program, "Time, Light, and Vision: The Art of Photography," written by Peter C. Bunnell. First significant European publication of his work and ideas in *Camera.*

1968 Extensive national lecture and printmaking demonstration schedule including Rhode Island School of Design, Massachusetts Institute of Technology, University of Iowa, Ohio University, Art Institute of Chicago, San Francisco Museum of Art, Purdue University, Addison Gallery of American Art, George Eastman Hause, The Friends of Photography, University of St. Thomas, and Wheaton College. Continues to present. Commissioned to create one of the "Great Ideas of Western Man" advertisements by the Container Corporation of America. First in-depth analysis of the body of his work by William E. Parker in *Aperture.*

1969 Appointed Professor of Art, University of Florida. Five photographs published as large format posters by the Poster Gallery, New York. Workshops at the Center of the Eye, Aspen and at Carmel under the auspices of the Friends of Photography. Teaches with Ansel Adams for the first time. Lectures and printmaking demonstrations at San Francisco State College, Austin College, Wheaton College, Northern Illinois University, and Florida Presbyterian College.

1970 Workshops at the Center of the Eye and University of California Extension, Berkeley. Lectures, frequently with printmaking demonstrations, at Santa Fe Junior College, Ohio University, Florida Technological University, Princeton University and New York University.

1971 Delivers the fourth Bertram Cox Memorial Lecture, entitled "Some Humanistic Considerations of Photography," at the Royal Photographic Society, London. The lecture is repeated in Southampton, Birmingham, Manchester, and Edinburgh. A prepared text appears in the *Photographic Journal,* March, 1971 and a shortened transcription of the London lecture in the same publication in April, 1971. Lectures and printmaking demonstrations at St. Lawrence University, Ringling Museum of Art, Boise State College, Idaho Art Association Conference, Image Circle, Georgia State University, and Atlanta Art Museum School. Workshops include University of Colorado, Center of the Eye, University of California Extension, Berkeley, and Imageworks. Attends the planning session for Imageworks in Lexington. Leave from the University of Florida for the academic year under a Faculty Development Grant. In October, cited for Special Recognition by the American Society of Magazine Photographers for "his outstanding contribution to photography."

1972 Receives National Endowment for the Arts Fellowship. Lectures at Birmingham Art Museum, Stetson University, Atlanta School of Art, School of Visual Arts, Georgia Professional Photographers Association, Rollins College, and in New York auspices of the International Fund for Concerned Photography. Workshop at Apeiron and participates in the Creative Experience Workshop under the auspices of the Friends of Photography. With Minor White organizes and participates in the Sippewissett Conference. Portfolio of ten original photographs, in an edition of twenty-five, issued by Witkin Gallery, New York.

1973 Made a Fellow of the Royal Photographic Society of Great Britain. Lectures at University of California Los Angeles, California Institute of the Arts, Santa Fe Junior College, and Columbia College. Conducts workshops at Portland State University, for the Ansel Adams Photography Workshop and the Friends of Photography.

ONE-MAN EXHIBITIONS

1960 Indiana University, Bloomington

1961 Illinois Institute of Technology, Chicago
San Francisco State College
University of Florida, Gainesville

1962 Indiana University, Bloomington
School of the Art Institute of Chicago

1963 Florida Union, University of Florida, Gainesville
Jacksonville Art Museum
Kalamazoo Art Institute

1964 Arizona State University, Phoenix

1965 University of South Florida, Tampa

1966 Lowe Art Gallery, University of Miami, Coral Gables
Pratt Institute, Brooklyn

1967 The Museum of Modern Art, New York*
Paul Creative Arts Center, University of
New Hampshire, Durham
Ringling Museum of Art, Sarasota

1968 Container Corporation of America, Chicago
Creative Photography Gallery, Massachusetts Institute
of Technology, Cambridge
N. W. Ayer Gallery, Philadelphia

Phoenix College
Photography at Oregon Gallery, University of Oregon
Museum of Art, Eugene
"Refocus," University of Iowa, Iowa City
Ringling Museum of Art, Sarasota**

1969 Camera Work Gallery, Costa Mesa
Carl Siembab Gallery, Boston
Friends of Photography, Carmel
University of South Florida, Tampa

1970 George Eastman House, Rochester**
Karyanna Gallery, Winter Park
Philadelphia Museum of Art*

1971 Boise State College, Boise
College of Idaho, Caldwell
St. Lawrence University, Canton

1972 The Art Institute of Chicago
Stetson University, Deland
Witkin Gallery, New York

1973 831 Gallery, Birmingham
University of Northern Iowa, Cedar Falls
Western Carolina University, Cullowhee

GROUP EXHIBITIONS

1958 Miami University, Oxford

1959 "Photographer's Choice," Indiana University,
Bloomington
"Photography at Mid-Century," George Eastman
House, Rochester*
State University College, Buffalo

1960 "Fotografi della Nuova Generazione," Milan
Image Gallery, New York
Rochester Institute of Technology

1962 "Photography-USA," DeCordova Museum, Lincoln*
"Three Photographers," George Eastman House,
Rochester

1963 Indiana University, Bloomington
"Photography 63," New York State Exposition, Syracuse
and George Eastman House*

1964 "Contemporary Photographs from the George Eastman
House Collection 1900-1964," New York World's Fair
and George Eastman House*
"The Heliographers," Westbank Gallery, Minneapolis
The Heliography Gallery, New York
The Heliography Gallery, New York (With Wynn Bullock)
"Lever House II: The Association of Heliographers,"
Lever House, New York
"Thirty Photographers," State University College,
Buffalo

1965 "Annual Faculty Exhibition," University of Florida,
Gainesville (Continues to present)
"A Special View of Nature," Florida State Museum,
University of Florida, Gainesville
"Photography in America 1850-1965," Yale University
Art Gallery, New Haven
"Six Photographers," Jacksonville Fine Arts Festival
"Six Photographers," Purdue University, Lafayette
"Six Photographers 1965," Krannert Art Museum,
University of Illinois, Champaign
20th Century Gallery, Williamsburg (With Paul Caponigro)

1966 "American Photography: The Sixties," University of
Nebraska, Lincoln
"Contemporary Photographers II," George Eastman
House, Rochester**
"Professors of Photography," University of Oregon,
Eugene*

1967 "Contemporary Photography Since 1950," George
Eastman House, Rochester**
The Edward Steichen Photography Center Galleries,
The Museum of Modern Art, New York
"First National Invitational Photography Exhibition,"
San Jose State College
"Four Photographers," Cummer Gallery of Art,
Jacksonville

"Persistence of Vision," George Eastman House, Rochester*

"Photography in the Fine Arts V," Metropolitan Museum of Art, New York

"Photography in the Twentieth Century," George Eastman House in collaboration with the National Gallery of Canada, Ottawa**

"The Portrait in Photography," Fogg Art Museum, Harvard University, Cambridge

1968 "Contemporary Photographs," University of California, Los Angeles

"Current Report II," The Museum of Modern Art, New York**

"Current Trends in Photography," University of New Hampshire, Durham

Focus Gallery, San Francisco (With Alfred Monner)

"Light⁷," Hayden Gallery, Massachusetts Institute of Technology, Cambridge*

"Photography as Printmaking," The Museum of Modern Art, New York*

"Photography USA," DeCordova Museum, Lincoln

1969 "A History of Photography: Photographs from the Collection of Peter C. Bunnell," Strauss Gallery, Dartmouth College, Hanover

"Human Concern/Personal Torment," The Whitney Museum of American Art, New York*

Florida State University, Tallahassee

"Images," Parsons School of Design, New York

"New Photography U.S.A.," International Council of The Museum of Modern Art**

"The Photograph as Object," National Gallery of Canada in collaboration with the Art Gallery of Ontario*

"Photographs for Collectors," The Museum of Modern Art, New York

"Photographs from the Coke Collection," Museum of Albuquerque*

"Portrait Photographs," The Museum of Modern Art, New York

"Thirteen Photographers," Pratt Institute, Brooklyn

1970 "The Innermost House," Creative Photography Gallery, Massachusetts Institute of Technology, Cambridge*

"Into the 70's," Akron Art Institute

"Terminal Landscapes—Photographic Images of Pastoral Ruins," George Eastman House, Rochester*

"12 x 12," Carr House Gallery, Rhode Island School of Design, Providence

1971 "Applied Color," George Eastman House, Rochester**

"The Artist as Adversary," The Museum of Modern Art, New York

"Contemporary Photography," State University College, New Paltz

"Eight Photographers," University of Rhode Island, Kingston

"Figure in Landscape," George Eastman House, Rochester*

"Groupe Libre Expression, Exposition V," Paris Humboldt State College, Arcata

Imageworks, Cambridge

"Photography," Skidmore College, Saratoga

"Photography Invitational 1971," Arkansas Art Center, Little Rock*

1972 "Beginnings," Pennsylvania State University, University Park

Birmingham Festival of the Arts, Birmingham

Cranfill Gallery, Dallas

"Four Directions in Modern Photography," Yale University Art Gallery, New Haven

"Landscapes," Ohio Silver Gallery, Los Angeles

"New Realism," Barry College, Mount Barry

"Octave of Prayer," Hayden Gallery, Massachusetts Institute of Technology, Cambridge

"Phases of New Realism" Lowe Art Museum, University of Miami

"The Photographer as Magician," University of California, Davis

"Photographs by American Masters," Museum of Fine Arts, St. Petersburg

"Portrait Photography," Moore College of Art, Philadelphia

"Portfolios," Galerie de Photographie de la Bibliothèque Nationale, Paris

1973 American Greetings Card Gallery, New York

"Contemporary Photographs," Princeton University Art Museum, Princeton

"Current Work," Unified Arts Lab, Albuquerque

"Photographs from the Coke Collection," Museum of New Mexico, Santa Fe

"Photography Into Art," Camden Arts Centre, London

"Photo-Phantasists," Florida State University, Tallahassee

"Three Photographers," University of Alabama, Birmingham

COMPREHENSIVE BIBLIOGRAPHY THROUGH 1970

Publications

Beadleston, Suzi, "Takes 'Special Effects' Seriously." *The Gainesville Sun*, October 22, 1966, n.p. Various quoted remarks.

"Gallery." *Life*, 67:8-11 (November 21, 1969). Untitled statement on the darkroom.

Great Ideas of Western Man. Chicago, Container Corporation of America, 1968 (Presentation piece). Interpretative statement on a photograph (191) commissioned for this series.

"Heliographers," *Photography Annual 1965*. New York, Ziff-Davis Publishing Co., 1964, p. 197. Untitled statement on personal approach to photography.

Into the 70's. Akron, Akron Art Institute, 1970. Untitled statement on the darkroom.

"Jerry N. Uelsmann." *Camera*, 46:6-19 (January, 1967). Excerpts from "Post-visualization" and an autobiographical essay.

"Jerry N. Uelsmann." *The Professional Photographer*, 94:96 (July, 1967). Untitled statement on personal approach to photography.

Kinzer, H. M., "Jerry Uelsmann: 'involved with the celebration of life'." *Popular Photography*, 57:136-143, 177-181 (November, 1965). Various quoted remarks.

"Shoot Now—Think Later." *Popular Photography*, 58:65, 101, (May, 1966). Excerpts from "Post-visualization."

Lyons, Nathan, "The Younger Generation." *Art in America*, 51:76 (December, 1963). Untitled statement on personal approach to photography.

Martin, Eunice Tall, "Jerry Uelsmann's World of Photography." *Floridalumnus*, 20:14-20 (Winter, 1968). Various quoted remarks.

"The Multiple Print." *The Camera*, Robert G. Mason and Norman Snyder, eds. New York, Time-Life Books, 1970, p. 44. Untitled statement on personal approach to photography.

"New Talent USA." *Art in America*, 50:49, No. 1 (1962). Untitled statement on personal approach to photography.

Parker, William E., *Eight Photographs: Jerry Uelsmann*. New York, Doubleday & Company, Inc., 1970. Various quoted remarks.

"Uelsmann's Unitary Reality." *Aperture*, 13:n.p., No. 3 (1967 [1968]). Various quoted remarks.

Photography Workshop/Summer 1970. Berkeley, University Extension, University of California, 1970 (Poster announcement). Untitled statement on post-visualization.

Scarbrough, Linda, "New Breed Foto Show at Modern Museum." *New York Daily News*, February 26, 1967, p. F2M. Statement on photography in relation to the arts of the nineteenth century and today.

Six Photographers 1965. Urbana, University of Illinois, 1965. Untitled statement on his photography.

"Three Photographers Exhibition." *Image*, 11:17-18, No. 4 (1962). Untitled statement on personal approach to photography.

12 x 12. Providence, Carr House Gallery, Rhode Island School of Design, 1970. Untitled statement on the darkroom.

Uelsmann, Jerry N., "Interrelationship of Image and Technique." *Invitational Teaching Conference at The George Eastman House*, Nathan Lyons, ed. Rochester, The George Eastman House, 1963, pp. 90-95. Reprinted in *Memo*, 1:185-187 (November, 1964).

"Post-visualization." *Florida Quarterly*, 1:82-89 (Summer, 1967). Reprinted in *Creative Camera*, 60-212-219 (June, 1969). Reprinted in *Contemporary Photographer*, 5:n.p., No. 4 (1967 [1970]).

"Wynn Bullock/Tracing the Roots of Man in Nature." *Modern Photography*, 34:89 (May, 1970).

White, Minor, ed., "Special Supplement in Honor of the Teaching Conference Sponsored by George Eastman House of Photography 1962." *Special Supplement Volume II (to Aperture)*, 1963, pp. 7-8. Statement on commitment to teaching photography.

Publications About

Beadleston, Suzi, "Takes 'Special Effects' Seriously." *The Gainesville Sun*, October 22, 1966, n.p. Various quoted remarks. Portrait photograph.

Beiler, Berthold, *Die Gewalt des Augenblicks*. Leipzig, VEB Fotokinoverlag, 1967. One photograph: 67.

Bry, Michael E., "Gallery Snooping." *Modern Photography*, 33:34, 36 (November, 1969). One photograph: 284. Review of "Friends of Photography" exhibition.

"Gallery Snooping." *Modern Photography*, 34:32 (October, 1970). Review of "Current Report II" exhibition.

Bunnell, Peter C., "Photography as Printmaking." *Artist's Proof*, Fritz Eichenberg, ed. New York, Pratt Graphics Center, 1969, pp. 24-40. One photograph: 233.

Coleman, A. D., "Latent Image." *Village Voice*, September 26, 1968, p. 20. Review of William E. Parker article in *Aperture*, 13:3 (1967).

"Creative Photography Display Set Up At IU." *Bloomington Herald-Telephone*. April 4, 1959, n.p. Review of "Photographer's Choice" exhibition.

Deschin, Jacob, "Color, Candids, Novelty." *The New York Times*, November 22, 1964, p. x17. Review of Uelsmann/Bullock exhibition at the Heliography Gallery.

"Finding Pictures in the Darkroom." *The New York Times*, February 19, 1967, p. 30D. Review of Museum of Modern Art exhibition. One photograph: 174.

"Group Exhibit." *The New York Times*, July 26, 1964, p. x16. Review of "Lever House II: The Association of Heliographers" exhibition.

"Pictures on View." *The New York Times*, January 26, 1964, p. x23. Review of four-man exhibition at the Heliography Gallery.

Fichter, Robert, "Alice Andrews." *Creative Camera*, 62:282-285 (August, 1969). Fictitious bibliographic footnote.

Fox, Phyllis, "I Celebrate My Life Through Photography." *Aspen Illustrated News*, July 30, 1969, pp. 7-9. Five photographs: 94, 323, 348, 400, 402.

Harker, Margaret F., "Sense and Perception." *The Photographic Journal*, 108:125-147 (May, 1968). Two photographs: 94, 174.

Hattersley, Ralph, "Games Photographers Play." *Photography Annual 1968*. New York, Ziff-Davis Publishing Co., 1967, pp. 14, 16, 16b, 18, 20, 22, 24, 30, 186, 191. Seven photographs: 209, 210, 212, 213, 215, 216, n.n.

"Heliographers," *Photography Annual 1965*. New York, Ziff-Davis Publishing Co., 1964, pp. 106-111, 197. Three photographs: 30, 56, 85.

"The Heliographers . . . a New Photographic Movement." *U.S. Camera and Travel*, 27:61, 64, 65 (May, 1964). One photograph: 81.

Hollyman, Tom, "In 1970, We Honor..." *Infinity*, 19:5-23 (September, 1970). Five photographs: 251, 284, 395, 397, 404.

Howell, Chauncey, "Art, etc." *Women's Wear Daily*, March 2, 1967, p. 28. Review of Museum of Modern Art exhibition.

"The Impact of Multiple Images," *The Print*,

Robert G. Mason, ed. New York, Time-Life Books, 1970, pp. 214-219. One photograph: 333.

"Jerry Uelsmann." *Infinity*, 11:22-26 (May, 1962). Five photographs: 12, 42, 43, 44, 60.

"Jerry Uelsmann." *The Professional Photographer*, 94:96 (July, 1967). Two photographs: 80, 174.

Kinzer, H. M., "Jerry Uelsmann: '...involved with the celebration of life.'" *Popular Photography*, 57:136-143, 177-181 (November, 1965). Eight photographs: 67, 80, 84, 98, 106, 118, 121, 125. "Letters to the Editor" (on the article). *Popular Photography*, 58:4 (January, 1966). Article reprinted in *Popular Photography Italiana*, 103:35-43, 48 (Gennaio, 1966).

"Shoot Now—Think Later." *Popular Photography*, 58:65, 101 (May, 1966). One photograph: 129.

Kramer, Hilton, "Portrait Photographs—A Historical Collision." *The New York Times*, September 14, 1969, p. D27. Review of "Portrait Photographs" exhibition.

Lyons, Nathan, ed., *The Persistence of Vision*. New York, Horizon Press, 1967. Eleven photographs: 57, 95, 98, 109, 116, 118, 146, 148, 155, 158, self-portrait.

Martin, Eunice Tall, "Jerry Uelsmann's World of Photography." *Floridalumnus*, 20:14-20 (Winter, 1968). Three photographs: 194, 251, 253, and eight portrait photographs by Helen Wallis.

Parker, William E., *Eight Photographs: Jerry Uelsmann*. New York, Doubleday & Company, Inc., 1970. Eight photographs: 80, 94, 200, 251, 324, 333, 374, 425.

"Notes on Uelsmann's Invented World." *Infinity*, 16:1, 4-13, 32-33 (February, 1967). Eleven photographs: 21, 31, 106, 142, 160, 168, 174, 184, 197, 198, 200.

"Uelsmann's Unitary Reality." *Aperture*, 13:n.p., No. 3 (1967 [1968]). Thirty-one photographs: 11, 14, 30, 31, 43, 52, 65, 67, 88, 94, 109, 124, 142, 143, 148, 153, 159, 162, 168, 181, 197, 198, 200, 204, 205, 233, 244, 251, 253, 259, 292.

Scarbrough, Linda, "New Breed Foto Show at Modern Museum." *New York Daily News*, February 26, 1967, p.F2M. Review of Museum of Modern Art exhibition. Portrait photograph by Evelyn Straus taken in gallery.

Smith, Henry Holmes, ed. *Photographer's Choice*. Bloomington, Henry Holmes Smith, 1959.

"The Photography of Jerry N. Uelsmann." *Contemporary Photographer*, 5:47-71, No. 1

(1964). Twenty-three photographs: 11, 12, 14, 29, 30, 31, 34, 42, 43, 52, 53, 56, 58, 60, 62, 65, 68, 78, 80, 81, 85, 88, 91. Picture selection and layout by the photographer.

"Special Issue on Photographic Education: University of Florida." *Infinity*, 18:16-19 (April, 1969).

"Le surréalisme en photographie." *Techniques graphiques*, 68:n.p. (1967). Three photographs: 89, 106, 156.

Szarkowski, John, *Jerry N. Uelsmann*. New York, The Museum of Modern Art, 1967 (Illustrated checklist). Six photographs: 56, 106, 109, 156, 199, 215. Essay reprinted in *Jerry N. Uelsmann*. Phoenix, Phoenix College, 1968 (Exhibition announcement). One photograph: 194.

"Toning Black-and-White Images," *Color*, Robert G. Mason, ed. New York, Time-Life Books, 1970, p. 222. One photograph (color): 373.

Ward, John L., *The Criticism of Photography As Art: The Photographs of Jerry Uelsmann*. Gainesville, University of Florida Press, 1970. Ten photographs: 34, 37, 56, 119, 204, 227, 228, 234, 339, 368.

White, Minor, "The Persistence of Vision." *Aperture*, 13:59-60, No. 4 (1968). Book review.

Williams, Hiram, "Five From Florida." *Art in America*, 50:132 (Summer, 1962).

Zucker, Harvey, "Multiple Images." *Popular Photography*, 62:112-115, 130 (June, 1968). One photograph: 137.

Photographs in Published Sources

American Photography: The Sixties. Lincoln, University of Nebraska, 1966. One photograph: 98.

An Appointment Calendar with Photographs from the Collection of The Museum of Modern Art (1967). New York, Museum of Modern Art, 1966. One photograph: 89.

"An Experiment with Line and Camera." *Journal of Commercial Art*, 2:40-45 (December, 1960). One design photograph: n.n.

"The Beautiful Image." *Popular Photography*, 59:86-91 (August, 1966). One photograph: 94.

Best Articles and Stories, 3:56 (September, 1959). One photograph: 1; 3:2 (October, 1959). One photograph: n.n.; 3:46 (November, 1959). One photograph: n.n.; 4:2 (March, 1960). One photograph: 3; 4:34 (April, 1960). One photograph: n.n.; 4:2 (June/July, 1960). One photograph: n.n.; 4:2 (September, 1960). One photograph: n.n.; 4:2 (October, 1960). One photograph: n.n.; 4:2 (November, 1960). One photograph: n.n.; 4:2 (December, 1960).

One photograph: n.n.; 5:2 (March, 1961). One photograph: n.n.; 5:2 (April, 1961). One photograph: n.n.; 5:2 (May, 1961). One photograph: n.n. Primarily reportage photographs used to illustrate various articles.

Bunnell Peter C., "Observations on Photographic Sensitivity." *Arts in Virginia*, 10:44-45, 64 (Winter, 1970). One photograph: 348.

"The Photographer as Printmaker." *Creative Camera*, 56:78-79 (February, 1969). One photograph: 233.

"Photographs for Collectors." *Art in America*, 56:70-75, January/February, 1968. One photograph: 148.

Bushman, John C., ed., *Real and Fantastic*. New York, Harper & Row, Publishers, 1970. Two photographs (details of each): 65, 359.

Cassirer, Ernst, *The Question of Jean-Jacques Rousseau*. Bloomington, Indiana University Press, 1963 (Cover). One design photograph: n.n.

The Center of Man/Micanopy. Micanopy, The Center of Man, 1969 (Announcement & brochure). One photograph: 251.

Contemporary Photographs. Los Angeles, University of California, 1968. One photograph: 374.

Deschin, Jacob, "Light Is Theme of Group Show." *The New York Times*, October 27, 1968, p. 36D. One photograph: 194.

Dunning, Stephen, and others, eds., *Reflections on a Gift of Watermelon Pickle....* New York, Lothrop, Lee & Shepard Company, Inc., 1967. One photograph: 85.

"Exhibitions Worth Seeing." *Famous Photographers Magazine*, 1:30-35 (Winter, 1967-1968). One photograph: 56.

The Florida Architect, 17:cover, 15 (September, 1967). One photograph: n.n.

Folio, 25:n.p. (Spring, 1960). Two photographs: 11, 13.

Four Photographers. Jacksonville, Cummer Gallery of Art, 1967. One photograph: 156.

"Gallery." *Life* 67:8-11 (November 21, 1969). Four photographs: 56, 67, 156, 333.

Great Ideas of Western Man. Chicago, Container Corporation of America, 1968. Various formats: as advertisement in numerous periodicals including *Newsweek*, 74:104 (September 15, 1969); as a presentation piece issued by the corporation; as a commercially distributed poster including Marboro Books, New York, which advertised it in *Esquire*, 72:21 (September, 1969); reproduced on verso of cover wrapper 68/69 *Graphis Annual*, Zurich,

Walter Herdeg, The Graphis Press, 1968. One photograph commissioned as a visual equivalent of a text by William Faulkner: 191.

Hall, James B. and Ulanov, Barry, eds., *Modern Culture and the Arts*. New York, McGraw-Hill Inc., 1967. One photograph: 358.

Human Concern/Personal Torment: The Grotesque in American Art. New York, Whitney Museum of American Art, 1969. One photograph: 358.

The Indiana School of the Sky. Bloomington, The Radio and Television Services, Indiana University, 1959-1960. Ten photographs: n.n.

Into the 70's. Akron, Akron Art Institute, 1970. Three photographs: 333, 404, self-portrait, photo-sculpture.

Jay, Bill, ed., "George Eastman House Special Issue." *Album*, 6:48 (July, 1970). One photograph: 348.

Jerry Uelsmann. Boston, Carl Siembab Gallery, 1969 (Exhibition announcement). One photograph: 253.

Jerry N. Uelsmann. Costa Mesa, Camera Work Gallery, 1969 (Exhibition announcement). One photograph: 333.

"Jerry N. Uelsmann: A Portfolio of Photographs." *The Liberal Context*, No. 17:14-19 (1966). Six photographs: 80, 107, 129, 148, 159, 164.

Journal of the American Association of University Women, 61:169 (May, 1968). One photograph: 98.

Keim, Jean A, "La Photographie: Made In U.S.A." *Les Nouvelles littéraires*, Aout 13, 1970, p. 10. One photograph: n.n.

"Kultur und Kritik." *Müncher Merkur*, Juli 17, 1970, p. 13. One photograph: 251.

Lsma/Elsma/Jerry Uelsmann. Carmel, The Friends of Photography, 1969 (Exhibition announcement). One photograph: 375.

Lyons, Nathan, ed., *Photography in the Twentieth Century*. New York, Horizon Press, 1967. One photograph: 87.

"The Younger Generation." *Art In America*, 51:72-77 (December, 1963). One photograph: 52.

Mack, Emily, "Photography at Mid-Century." *Infinity*, 8:10 (December, 1959). One photograph: 9 (incorrect orientation).

Man. Evanston, McDougal, Littell & Company, 1970. Series of literary anthologies with various editors. *Man in the Dramatic Mode*, 3:54. One photograph: 87; 5:36, 42-43. One photograph (with detail); 109; 6:60, 77. One photograph (with detail): 88. *Man in the Expository Mode*, 5:146. One photograph: 244. *Man in the Fictional Mode*, 6:44. One photograph: 57. *Man in the Poetic Mode*, 3:vi. One photograph: 107; 4:vi, 43, 111. Three photographs: 137, 200, 251; 6:22, 93. Two photographs: 12, 253.

New Photography USA. Bonn-Bad Godesberg, United States Information Agency, 1970. One photograph: 251.

"New Talent USA." *Art in America*, 50:49, No. 1 (1962). One photograph: 29.

"The Multiple Print," *The Camera*. Robert G. Mason and Norman Snyder, eds. New York, Time-Life Books, 1970, pp. 44-45. One photograph: 233.

The Persistence of Vision. Baltimore, Maryland Institute of Art, 1969 (Exhibition announcement). One photograph: 98.

The Persistence of Vision. Rochester, George Eastman House, 1967 (Exhibition poster). One photograph: 158.

The Photograph as Object 1843-1969. Ottawa, The National Gallery of Canada, 1970. One photograph: 233.

Photography Annual 1957. New York, Ziff-Davis Publishing Co., 1956. One photograph: n.n.

Photography Annual 1958. New York, Ziff-Davis Publishing Co., 1957. One photograph: 1.

Photography Annual 1965. New York, Ziff-Davis Publishing Co., 1964. One photograph: 52.

Photography Annual 1967. New York, Ziff-Davis Publishing Co., 1966. Two photographs: 138, 162.

Photography at Mid-Century. Rochester, George Eastman House, 1959. One photograph: 9.

"Photography at Mid-Century," *U.S. Camera 1961*. New York, U.S. Camera Publishing Corp., 1960, p. 257. One photograph: 9.

Photography in America 1850-1965. New Haven, Yale University Art Gallery, 1965. One photograph: 56.

Photography 63. Rochester, George Eastman House, 1963. One photograph: 52.

Photography USA. Lincoln, DeCordova Museum, 1968. One photograph: 80.

Photography Workshop/Summer 1970. Berkeley, University Extension, University of California, 1970 (Poster announcement). One photograph: 397.

Porter, Allan, ed., "Jerry N. Uelsmann." *Camera*, 46:6-19 (January, 1967). Twelve photographs: 30, 56, 60, 80, 85, 94, 106, 107, 137, 142, 153, 200.

The Poster Gallery, New York. Five large format posters issued 1969. Five photographs: 148, 162, 204, 251, 259. Full format reproduction using photograph 259: *Famous Photographers Magazine*, 3:27, No. 10 (1970).

"The Power of Seeing." *Life*, 61:142-143 (December 23, 1966). One photograph: 80.

Racanicchi, Piero, "Photography '63." *Popular Photography Italiana*, 87:43-48 (Settembre, 1964). One photograph: 52.

Seven, Spring, 1968, pp. 3-5. Three photographs: 30, 77, 178.

Six Photographers 1965. Urbana, University of Illinois, 1965. Two photographs: 107, self-portrait.

Thirty Photographers. Buffalo, State University College, 1964. One photograph: 105.

"Three Photographers Exhibition." *Image*, 11:17-18, No. 4 (1962). One photograph: n.n. (variant of 136).

12 x 12. Providence, Carr House Gallery, Rhode Island School of Design, 1970. Two photographs: 419, 425.

Uelsmann, Jerry N., "Jerry N. Uelsmann: Postvisualization." *Creative Camera*, 60:212-219 (June, 1969). Seven photographs: 109, 156, 172, 251, 333, 361, 374.

"Post-visualization." *Florida Quarterly*, 1:82-89 (Summer, 1967). Four photographs: 56, 94, 106, 107.

Wasserman, Emily, "Photography." *Artforum*, 6:71-74 (Summer, 1968). One photograph: 233.

White, Minor, "Light[7]." *Aperture*, 14:8, 51, No. 1 (1968). Also *Light[7]*. Cambridge, M.I.T. Press, 1968. Two photographs: 194, 339.

I have adhered to the following guidelines in compiling this information. A single asterisk (*) indicates that the exhibition was circulated by the institution whose name follows the title. A double asterisk (**) indicates that the exhibition was organized by the institution listed for circulation only. Entries for circulating exhibitions have not been listed beyond that location where the exhibition was first shown. The numbers which conclude the bibliographic entries identify the specific photographs reproduced and correspond to the chronological index of some 428 Uelsmann photographs dating between 1956 and 1969. Copies of this index exist at The Alfred Stieglitz Center of The Philadelphia Museum of Art and in the Department of Photography, The Museum of Modern Art, New York.

Peter C. Bunnell

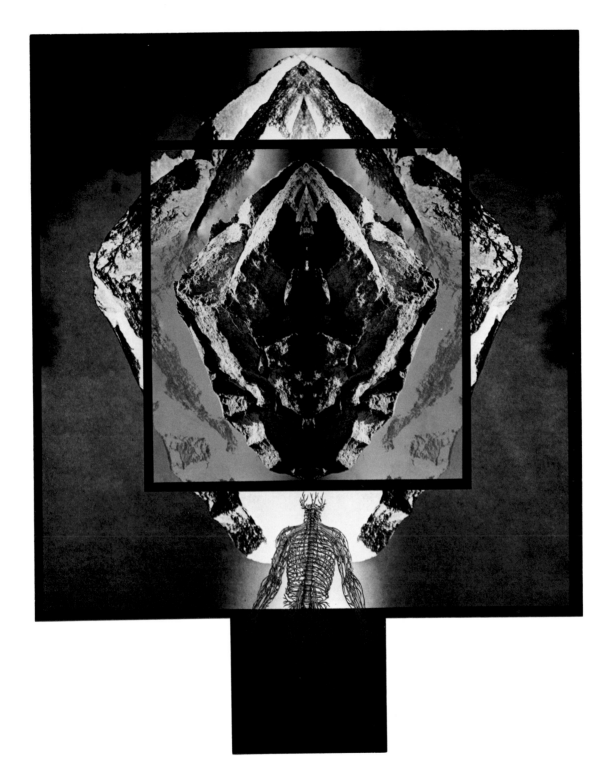

1968

Russell Edson's fables contained herein were selected from *The Very Thing That Happens*, New Directions Publishing Corporation; *What a Man Can See*, The Jargon Society; *The Brain Kitchen*, Thing Press. The fables are used with the kind permission of the publishers and the author.

For assistance in compiling the bibliography we wish to thank Henry Holmes Smith of Indiana University for locating examples of early published work. Robert Sobieszek and Harold Jones, both of George Eastman House, were helpful with numerous inquiries. William E. Parker generously shared his own research on and correspondence with Jerry Uelsmann.